DESIGNERS ON INSTAGRAM

#FASHION

THE COUNCIL OF FASHION DESIGNERS OF AMERICA

ABRAMS, NEW YORK

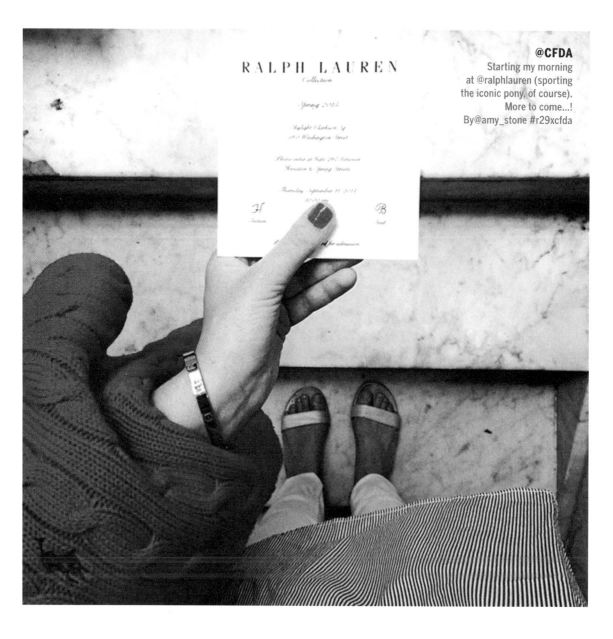

#CONTENTS

FOREWORD

THE POWER OF AN IMAGE IS something everyone understands. As humans, we look for ways to record a moment we know we may never get back. From cave paintings 40,000 years ago to more recent sculptures, paintings, photographs, and movies, each has helped shape the way we communicate and understand one another. Transcending the limits of language, geography, and time, a visual image taps into our most basic senses and creates an experience that can be uniquely personal or profoundly connective.

The emotional connection through images is what has inspired and humbled us most about the Instagram community over the past four years. And no industry has brought that connection to life more than fashion. From the everyday to the incredible, people are capturing and sharing moments that might have otherwise been forgotten.

This collection of photographs compiled by the Council of Fashion Designers of America (CFDA) is a unique glimpse into the personal, authentic, and beautiful images shared on Instagram by everyone who touches the fashion industry. From makeup artists and emerging designers to the models and most-loved fashion houses, this community has introduced a new era of creative storytelling through fashion.

Personally, I have always been fascinated by craft—that precision and commitment to getting something just right, whether it is the perfect latte or a beautiful handmade watch. Like Instagram itself, fashion is driven by visuals. It is a medium that pushes boundaries, and is famous for dedicating painstaking effort to the designs they showcase and to how they are presented to the larger world. Bringing every new collection to life—the runway presentations, print campaigns, television ads—is as much a part of the creative process as the color, material, and craftsmanship of the clothing and accessories.

Designers and photographers understand, perhaps more than anyone, the power of visual imagery. Whether it's through the September issue of *Vogue* or catching a glimpse backstage at Prabal Gurung's show via my Instagram feed, I want to see what's going on in fashion. And the great thing is that that can happen on a billboard, inside a store, or through social media—designers know the impact of a visual, and are committed to delivering the highest caliber of quality and style.

Even fashion magazines and columns are powered by pictures. We saw it first as illustrations, then photographs, and now through multimedia online and on mobile. Our culture has shifted to communicating visually, particularly in this space. Social media has opened a whole new world of inspiration, aggregating all the different facets of creative development, and allows us to interact with fashion in brand-new ways. I have had the privilege to attend a handful of shows myself, and I have been fortunate enough to meet design icons like Christopher Bailey, Diane von Furstenberg, and the late Oscar de la Renta. But, thanks to my phone, I was able to follow along way before being invited into their world, and through social media I saw the inspiration for their collections, the runway shows, and all the moments in between that

make fashion such a special experience.

Today's technology allows almost everyone to be a photographer—and a very good one—which has revolutionized our collective relationship with style. Plenty of people have walked around New York City with a camera on a strap slung across their body, or perhaps traveled across Europe with a handheld camcorder in their backpack. But that took effort. They had to plan ahead, pack their film, remember the battery charger, and carry something extra. For the vast majority of everyday people, these tools were not "essentials." And as a result, capturing a moment became planned, not something that could happen right at the second something truly caught your eye.

For most of us, it is now hard to imagine going anywhere without our phones. It's your home base for everything—your friends, your job, your family—and your hub for all forms of communication both private and public. It's more than likely that the phone you have with you also constantly allows you to take beautiful, high-resolution photos. It has been said that mobile technology has attached cameras to cell phones, but it's the opposite: We've added a network to our cameras. This has democratized fashion, and the book in front of you is the real-life result.

You have a unique storytelling platform and a phone that is more powerful than the computer that sent humans to the moon in 1969 right at your fingertips. Now what?

The imaginative individuals who contributed to this book represent best-in-class examples of storytelling on Instagram. They take what they see and relay it directly into the world through Instagram. If you love fashion, you are likely passionate about every aspect of it. That passion is evident in this collection of photos submitted by some of America's most visionary and creative minds. The people who follow these designers are then able to share in that moment, whether it is a video of J.Crew's runway finale or a glimpse into the distinctly clean, crisp world of Thom Browne. By following the style and design community myself, I have seen firsthand how these people can make ordinary look and feel extraordinary.

The fashion community on Instagram teaches us the art of how to simply and powerfully unlock a story. The stories that fill these pages captivate my imagination and illustrate how the CFDA continues to raise the creative bar for all things #fashion.

—KEVIN SYSTROM, CO-FOUNDER AND CHIEF EXECUTIVE OFFICER, INSTAGRAM

INTRODUCTION

FASHION APPEALS TO ALL of our senses. We can feel the softness of cashmere and smell newly crafted leather. We can hear the unzipping of a weekend bag telegraphing the excitement to come. And designers can taste success when a collection has flown off the shelves. But there is perhaps no stronger sense connected to fashion than sight. And each fashion week, I am amazed as collections come to life.

For many years, fashion was exclusive to the fashion industry. Inside the confines of Fashion Week tents and pavilions, people were denied access to one of the most momentous occasions in the fashion industry. And it wasn't just Fashion Week. People outside of key fashion markets—New York, London, Paris, Milan—didn't have an instant and direct way to keep up with the industry as a whole.

In 2010, two very innovative men named Kevin Systrom and Mike Krieger came up with a photo-sharing platform that would unequivocally change the landscape of fashion forever. Instagram broke down the barrier between everyday people and the fashion industry—and opened the door for reciprocal communication between designers and the rest of the world.

Using Instagram, a designer can test a customer's response to a new handbag. If a designer wants to showcase the process leading up to a collection, they can chronicle their journey from the sketch stage to center stage. When some designers want to show us how they derived inspiration for their latest collections, they will use Instagram as the medium to showcase their journeys across the globe. Whether it was a day spent immersed in the ruins of Pompeii or time spent sailing the glistening Aegean, we are there to watch how inspiration is instantaneously metabolized and used by designers to create. We now have a bird's-eye view into the inner workings of their talent and craft.

At the CFDA our mission statement is to strengthen the influence and success of the American fashion industry. Instagram is one of the strongest mediums for accomplishing this goal. Not only does the CFDA use Instagram to showcase to the rest of the world the strength of American fashion through the work we do with students, emerging designers, and philanthropy, but our talented roster of designers are also highlighting their strengths on an international level. If designers want to reach customers in different parts of the world, they can snap a photo when they are in China and inform followers of a new store opening, for example. I was in Mexico City recently and it was through Instagram that CFDA member Cheryl Finnegan, who is headquartered there, learned about my stay and connected with me.

And many of our designers have not only embraced Instagram, they have used it in unparalleled ways. Perhaps there is no better example than when Oscar de la Renta debuted

his fall campaign in July 2013 on OscarPRgirl's Instagram account weeks before any major fashion books were privy. Fans who loyally follow the brand felt like they were getting access to something before anyone else. The campaign also defied traditional marketing practices and set the stage for many brand strategies to come.

The CFDA has also toyed with iconoclastic digital practices. This past year, for the first time at the CFDA Fashion Awards, we created an "Instagrammer of the Year" award. Our number of followers increased on this night more than any other in our history. People who were unfamiliar now understand our organization and some of its goals.

Just like Instagram, the CFDA has always followed an ethos of inclusivity. We continue to grow each year, and we support and nourish American fashion designers from the earliest stages of their lifecycle. The preexisting walls between the fashion industry and the world have been eradicated, and we're only moving forward. I'm so pleased to share with you the complete aggregation of Instagram images captured by our designers. This is the CFDA's ninth book, and I can confidently say that our members have never been more excited. Our members love this platform, and I do too. We hope you will continue to follow them on their journeys. Each designer is unique and has a different way of sharing his or her narrative. And though a photo or moment may be ephemeral, you can now have these images at your fingertips, in one place, to view forever and whenever you desire.

Photography has always been at the core of fashion. Some of the best photographers of our time have been there to capture fashion's most iconic moments. But with Instagram, our designers and you have the chance to create your own iconic worlds. With a snap, caption, filter, and post, you too can contribute to the world of #fashion.

—STEVEN KOLB, CHIEF EXECUTIVE OFFICER, CFDA

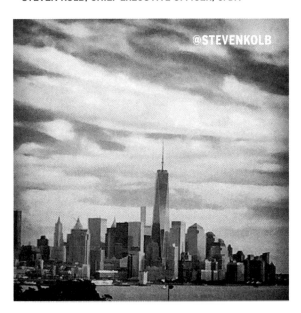

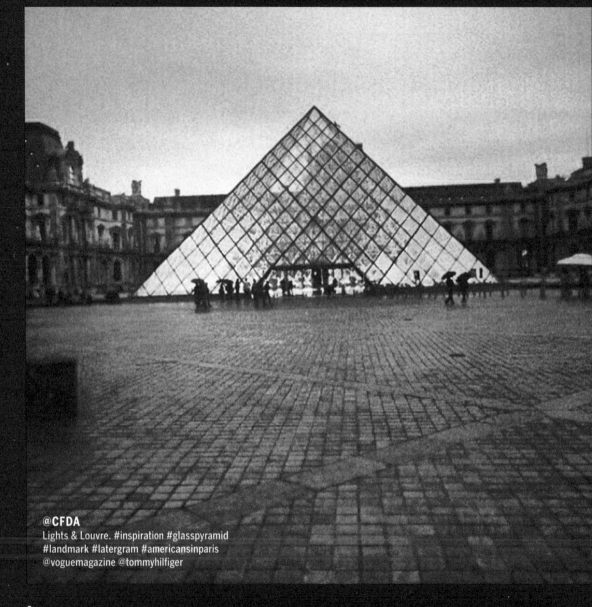

@CFDA
Lights & Louvre. #inspiration #glasspyramid
#landmark #latergram #americansinparis
@voguemagazine @tommyhilfiger

8

@KERENCRAIGMARCHESA

@ARAKS_YERAMYAN

@EVAFEHREN

@MPATMOS

#INSPIRATION

@NICHOLASKSTUDIO

@LUISFERN5

@AMOURVERT

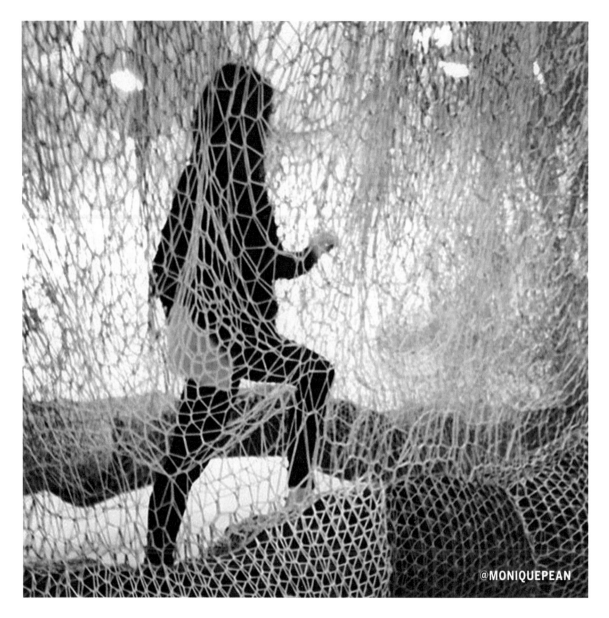

@MONIQUEPEAN

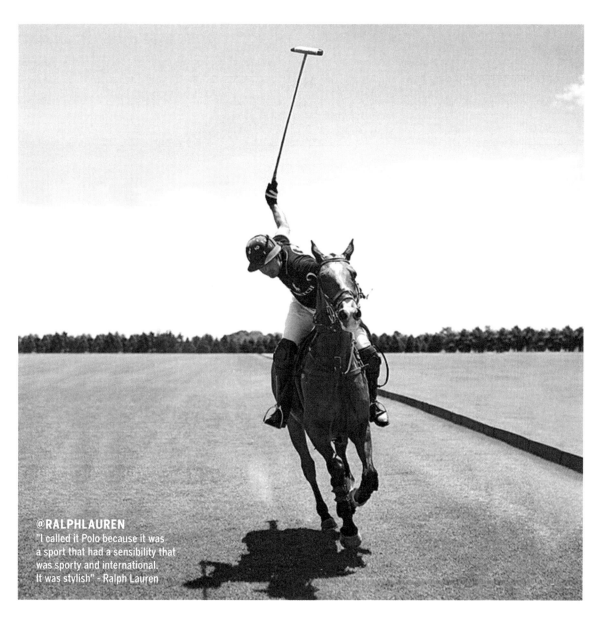

@RALPHLAUREN
"I called it Polo because it was a sport that had a sensibility that was sporty and international. It was stylish" - Ralph Lauren

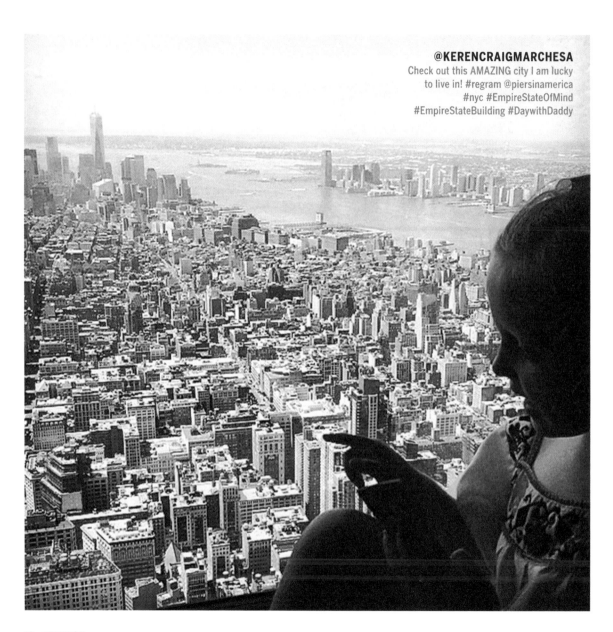

@KERENCRAIGMARCHESA
Check out this AMAZING city I am lucky
to live in! #regram @piersinamerica
#nyc #EmpireStateOfMind
#EmpireStateBuilding #DaywithDaddy

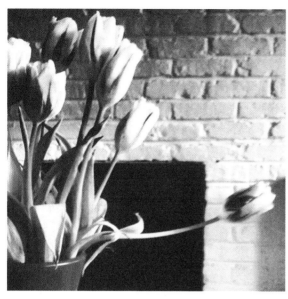

← **@MPATMOS**
#beautiful #winter #tulips #vintage
#ceramic #vase #love #instagood

↙ **@NICOLEMILLERNYC**
@nicolemillernyc Leaving manhattan

↓ **@LAURAPORETZKY**

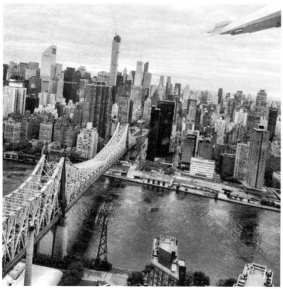

@SHELLYSTEFFEE

@GGUBLO67

@MARCALARY

@DVF

@JEFFHALMOS_

@KATESPADENY

@KERENCRAIGMARCHESA

@MARCJACOBSINTL

@CHILIDROD

@VSA_DESIGNS

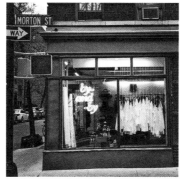

@JUSSARALEE

@KATESPADENY

@XOBETSEYJOHNSON

@MELISSAJOYMANNING

@LEMLEMNYC

@HEISEL_CO

@DEREKLAMNYC

@EUGENIAKIMNYC

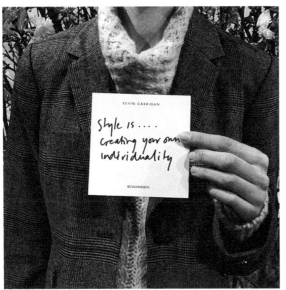

@CALVINKLEIN ↑
"Style is...creating your own individuality,"
- Kevin Carrigan, Global Creative Director.
#F14 Calvin Klein white label press preview.

@EUGENIAKIMNYC
EK Interns cooling off with some Italian Ice!
#summerinthecity ↗

@CHARLOTTERONSON ↗
Our last day in #Aruba 🌴🐟.
Sad to go 😫 @arubainstyle

→

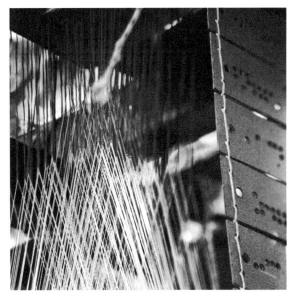

@MAIYET →
Looms in Varanasi #varanasiproject
#rareandunexpected

@ALC_LTD ↘
A.L.C. #TribeTalkSeries #SoGood

@ARAKS_YERAMYAN ↓
Almost finished

"BE SO GOOD
THEY CAN'T IGNORE YOU"
- STEVE MARTIN

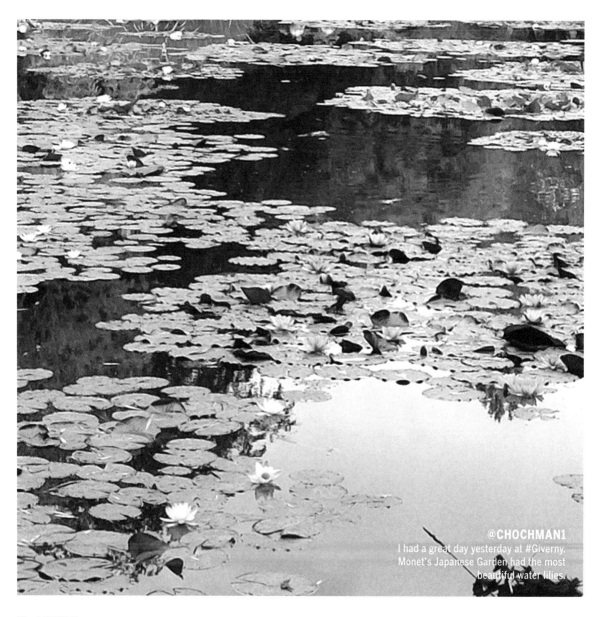

@CHOCHMAN1
I had a great day yesterday at #Giverny.
Monet's Japanese Garden had the most
beautiful water lilies.

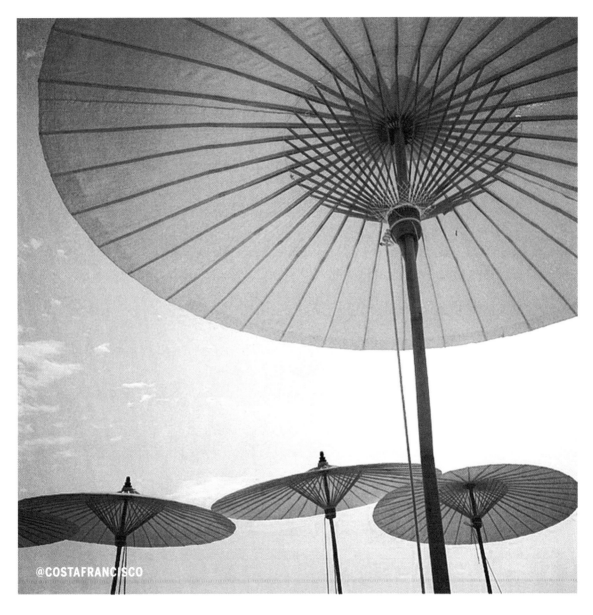

@COSTAFRANCISCO

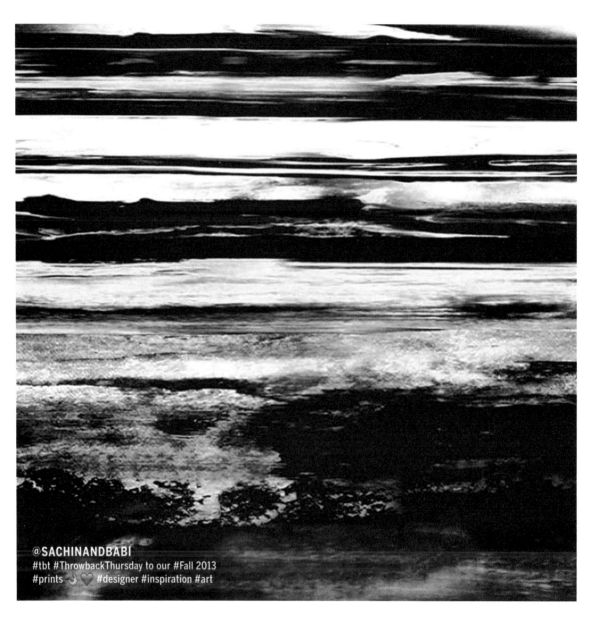

@SACHINANDBABI
#tbt #ThrowbackThursday to our #Fall 2013
#prints 👉 🤍 #designer #inspiration #art

@EVAFEHREN →
Work in progress #infetish
#blackandwhite #evafehren #studioday

@MELISSAJOYMANNING ↘
#chrysoprase slices- heavenly.
#gjx #tucsongemshow

@JEFFHALMOS_ ↓
On guard #exumas #nofilter

@APOLIS ↑
We're thankful for a fun weekend to
relax with our family and remember the
American men and women who
have made great sacrifices for us to enjoy
a textbook #MemorialDay in an
incredible part of the country!
Special thanks to @newyorksunshine
for letting us borrow a couple boards!

@DONNAKARANTHEWOMAN ↗
Mother Nature at her best. Sun on my back
and thunder storm out to sea. Thank you!

@LUISFERN5 →
friday #BLUE's HUEs // #officeview
#jj_forum_0897 #beach #jjbeach
#tltransportme #landscape #ocean

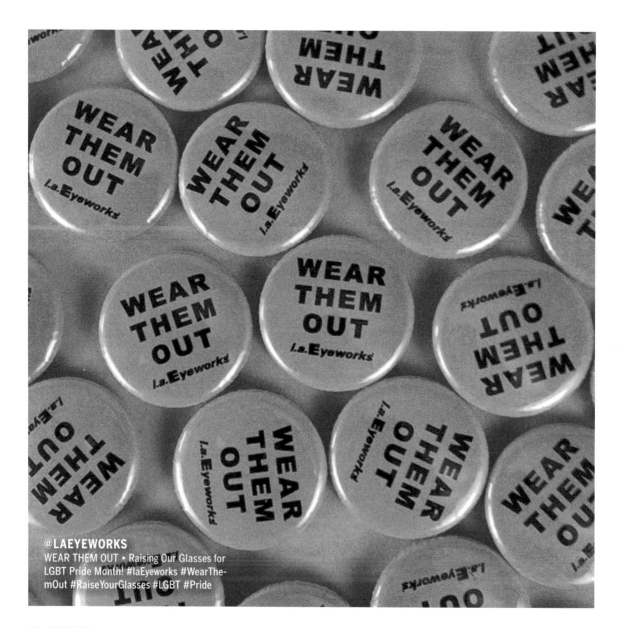

@LAEYEWORKS
WEAR THEM OUT • Raising Our Glasses for
LGBT Pride Month! #laEyeworks #WearThem-
mOut #RaiseYourGlasses #LGBT #Pride

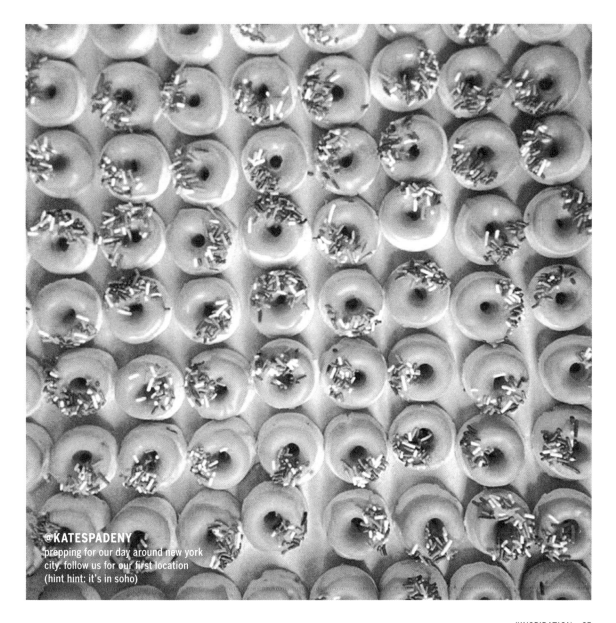

@KATESPADENY
prepping for our day around new york
city. follow us for our first location
(hint hint: it's in soho)

@BILLY_REID

@BOTKIER

@CHILIDROD

@SACHINANDBABI

@REEM_ACRA

@RACHELZOE

@THAKOONNY

@XOBETSEYJOHNSON

@VERONICABEARD

@DENNISBASSO

@ERNESTALEXANDER

@MILLYBYMICHELLE

@ALBERTUS_SWANEPOEL

@SULLYBONNELLY

@ALEXANDREBIRMAN

@SALVATORECESARANI

@BURKMANBROS

@TRACY_REESE

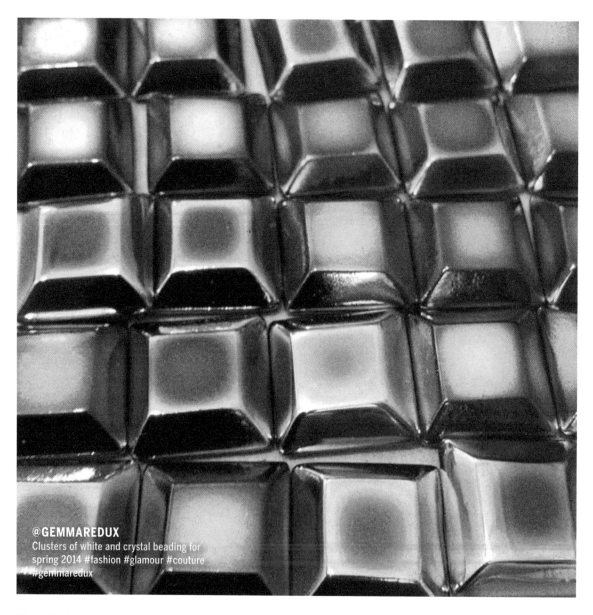

@GEMMAREDUX
Clusters of white and crystal beading for
spring 2014 #fashion #glamour #couture
#gemmaredux

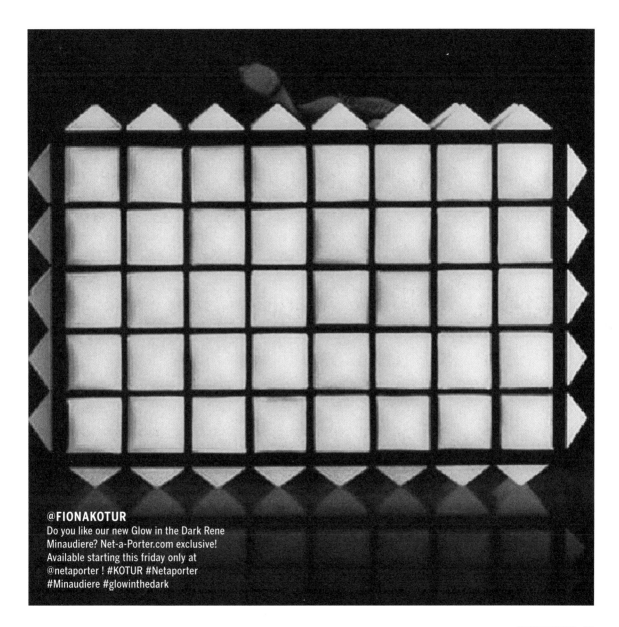

@FIONAKOTUR
Do you like our new Glow in the Dark Rene
Minaudiere? Net-a-Porter.com exclusive!
Available starting this friday only at
@netaporter ! #KOTUR #Netaporter
#Minaudiere #glowinthedark

← **@ALBERTUS_SWANEPOEL**
#africanskies #nofilter incredible

↙ **@PAMELLAROLAND**
Had an amazing time at the Latin Fusion
restaurant Coco Maya in the British Virgin
Islands. The view was so beautiful
#springbreak

↓ **@TOMS**
Come with us this season as we dive
deeper into our Guatemala story and learn
more with each bend in the road.
Come #discoverTOMS

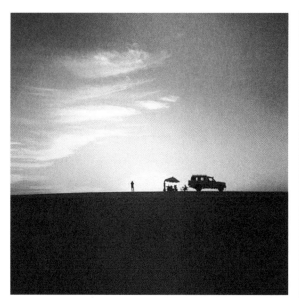

↖ **@RODKEENANNEWYORK**
Sundowners

↑ **@CHERESKINSTUDIO**
Fire Island

← **@THISISBANDOFOUTSIDERS**
#LA.

@EVAFEHREN
On my way...I missed you. #iheartnewyork
#efxny #evafehren

@JCOBANDO →
What's up Kimosabi!

@NANETTELEPORE ↘
Fact.

@31PHILLIPLIM ↓
Delve into the #31world for some
#inspirational imagery this weekend!
31philliplim.com

It's a very cool thing to be
a smart girl.

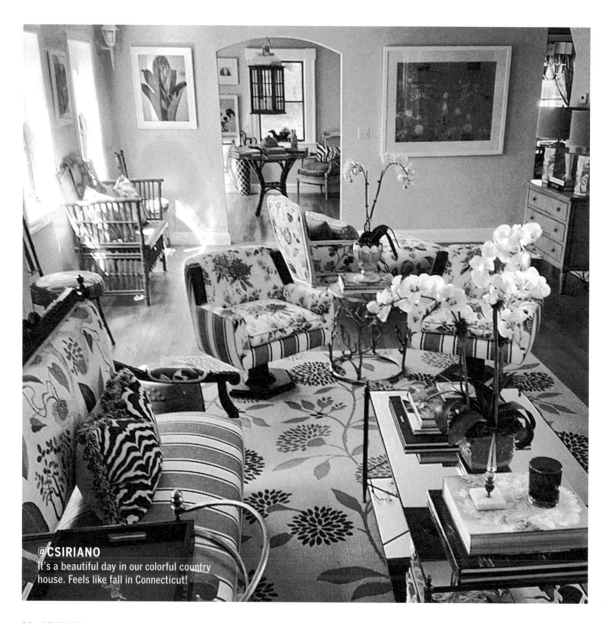

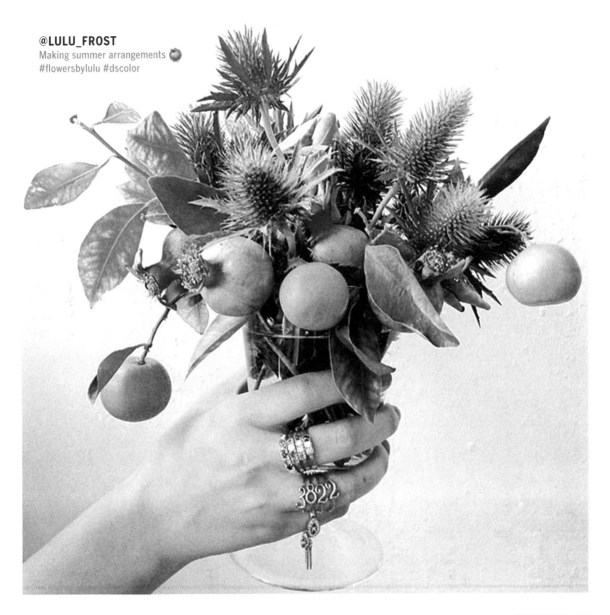

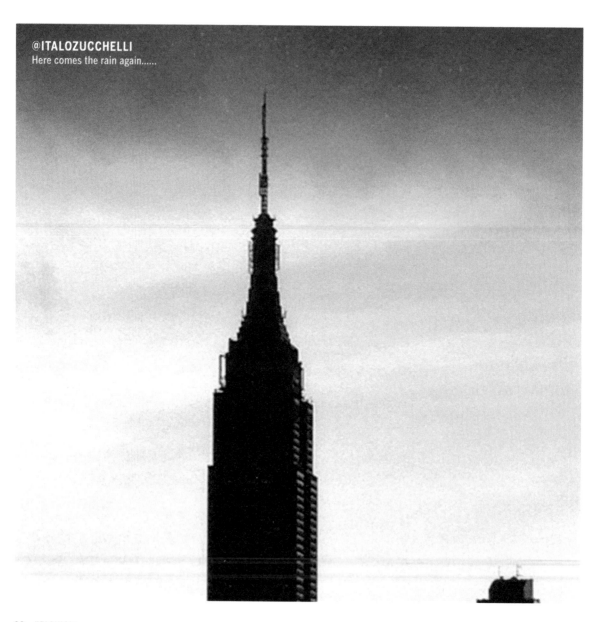

@**ITALOZUCCHELLI**
Here comes the rain again......

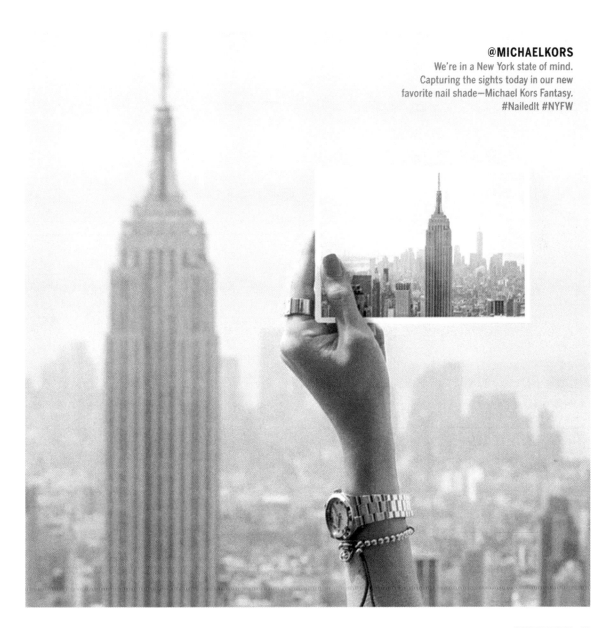

@CHILIDROD

@COSTAFRANCISCO

@LEMLEMNYC

@DONNAKARANTHEWOMAN

@PAUL_MARLOW

@CYNTHIAVINCENT

MISS FLORENCE TODAY!

@GIULIETTANEWYORK

@COLETTEMALOUF

@NICHOLASKSTUDIO

38

@NANETTELEPORE

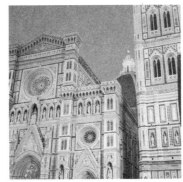

@OFFICIALRODARTE

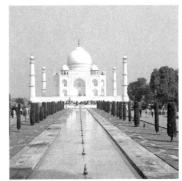

@RICHARDLAMBERTSON

@CLAREVIVIER

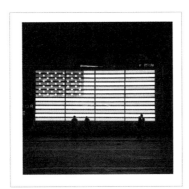

@BILLY_REID

@LISAJENKSJEWEL

@RACHELZOE

@MATTMURPHYNYC

@ULRICHCPS

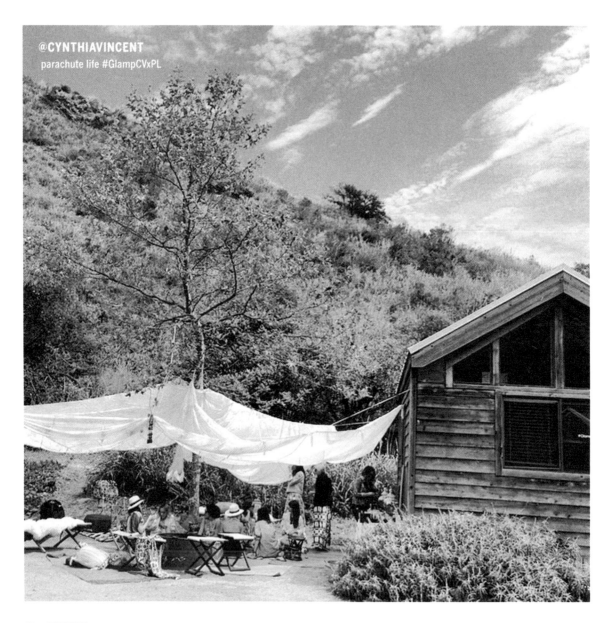

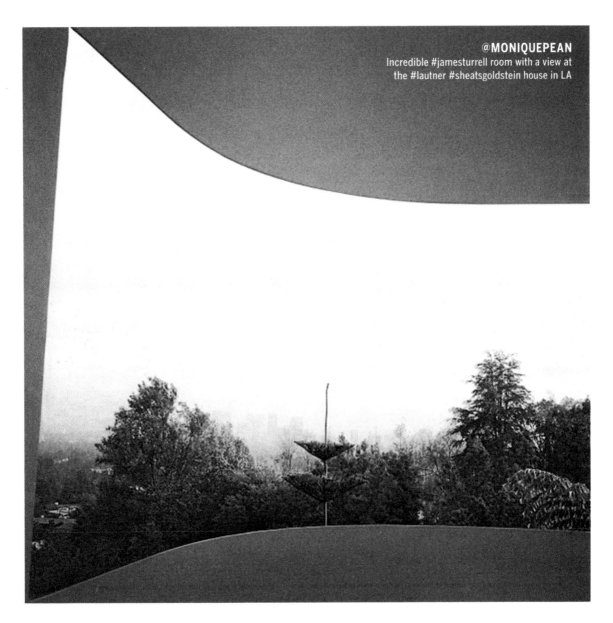

@**MONIQUEPEAN**
Incredible #jamesturrell room with a view at
the #lautner #sheatsgoldstein house in LA

@BURKMANBROS ↑
Inspired by leisure. #Moodboard
#behindtheseams @cfda

@SALVATORECESARANI ↗
Timeless fabrics with new proportions...
Cesarani Style

@BILLY_REID →
Model tatts x Brewton Popovet.
#summer14 #forttryon

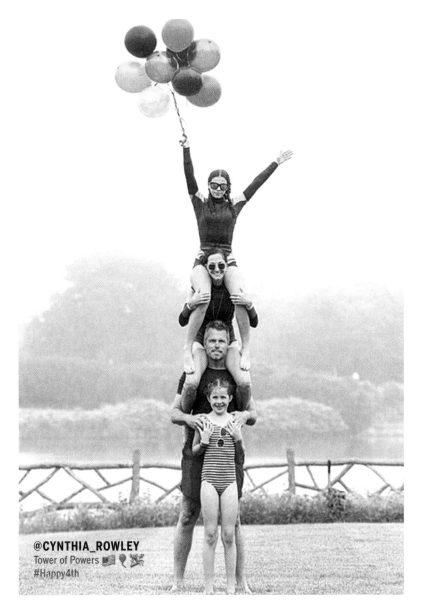

@CYNTHIA_ROWLEY
Tower of Powers 🇺🇸 🎈 💥
#Happy4th

↖ **@NICOLEMILLERNYC**
back to nyc!

↑ **@PAUL_MARLOW**
#morrislouis #hirsshorn

← **@WHIT_NY**
The latest in stripe technology!

@TRINATURK ↑
#trinaturkprint coming in February...
#trinaturkspring2014

@TORYBURCH ↗
Loved Shanghai...

@SUESTEMP →
Good Morning Legoland
#EverythingIsAwesome

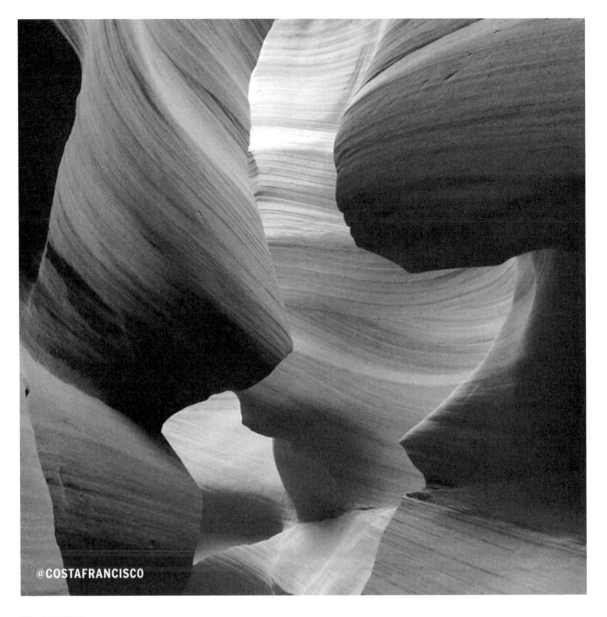

@COSTAFRANCISCO

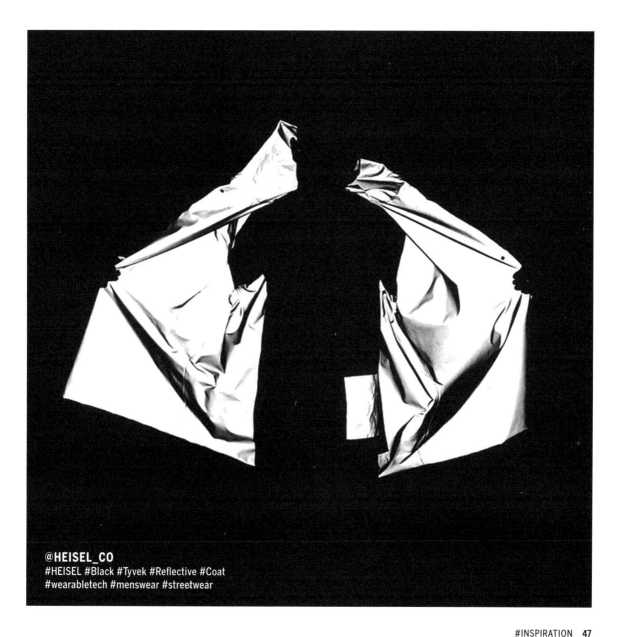

@HEISEL_CO
#HEISEL #Black #Tyvek #Reflective #Coat
#wearabletech #menswear #streetwear

@ALICEANDOLIVIA

@LISAJENKSJEWEL

@SUESTEMP

> *I SEE*
> *BOLD ACCESSORIES*
> *AS A*
> *WOMAN'S ARMOR.*

RACHEL ZOE
#LIVINGINSTYLE

@RACHELZOE

@SLOWANDSTEADYWINSTHERACE

@GGUBLO67

@JCOBANDO

@CYNTHIA_ROWLEY

@KIMBERLYMCDONALDJEWELRY

I DON'T STOP FOR COPS

@OFFICIALLIBERTINE
Sup

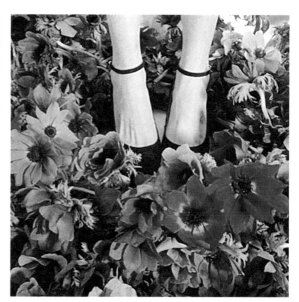

@AMOURVERT ↑
Today's plumetis socks + jeans + beach
situation #inappropriate #wrongoutfit #what-
wasithinking

@WHIT_NY ↗
Blizzard outside, but the lookbook shoot
must go on! #fashion #winter florals

@MATTMURPHYNYC →

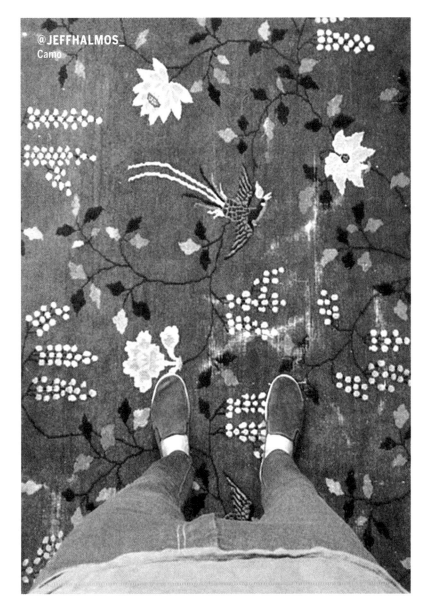

@JEFFHALMOS_
Camo

@TRINATURK

@THISISBANDOFOUTSIDERS

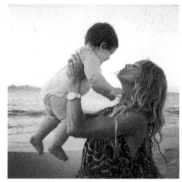

@RACHELZOE

@DVF

@CHERESKINSTUDIO

@SKEARNEY73

@MARAHOFFMAN

@RICHARDLAMBERTSON

@SUESTEMP

@WHIT_NY

@AMSALEBRIDAL

@DONNAKARANTHEWOMAN

@THEELDERSTATESMANOFFICIAL

@MONIQUELHUILLIER

@PETERSOM

@CYNTHIAVINCENT

@VERAWANGGANG

@HOUSEOFHERRERA

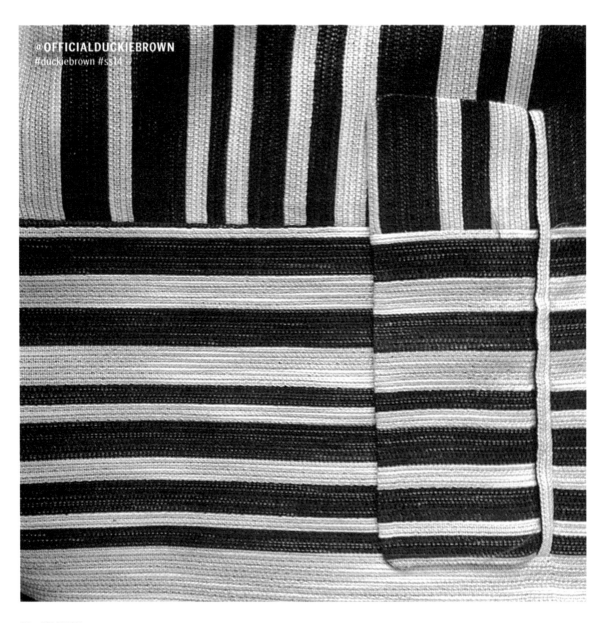

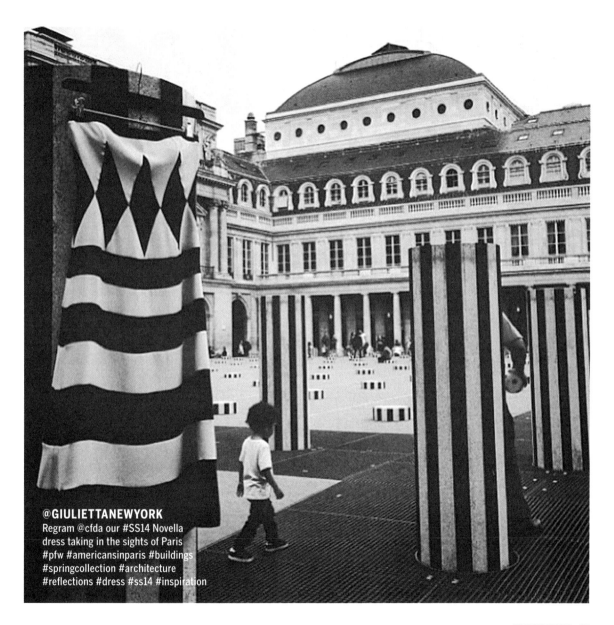

@GIULIETTANEWYORK
Regram @cfda our #SS14 Novella
dress taking in the sights of Paris
#pfw #americansinparis #buildings
#springcollection #architecture
#reflections #dress #ss14 #inspiration

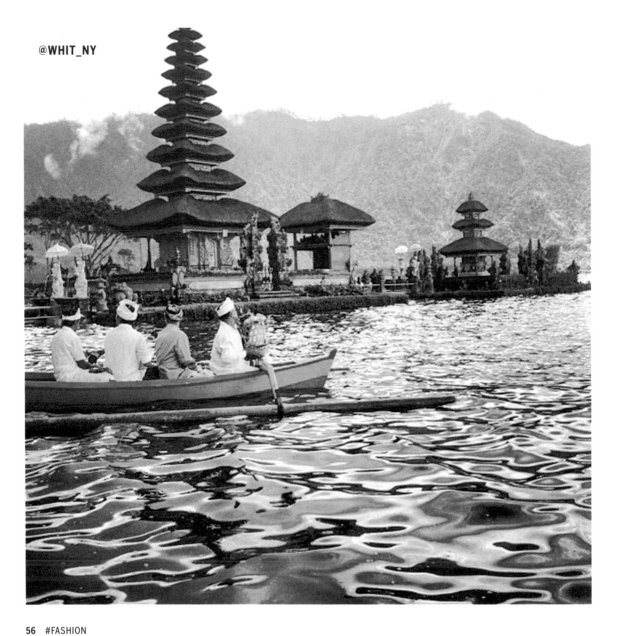

↖ **@REEDKRAKOFF**
#Summer starts this #Weekend #PalmBeach #MemorialDay #Luxury #Inspiration #design #fashion #RK #ReedKrakoff

↑ **@NICHOLASKSTUDIO**
#llaollao#bariloche #argentina

← **@TABITHASIMMONS**
Lunch in Venice 🍴

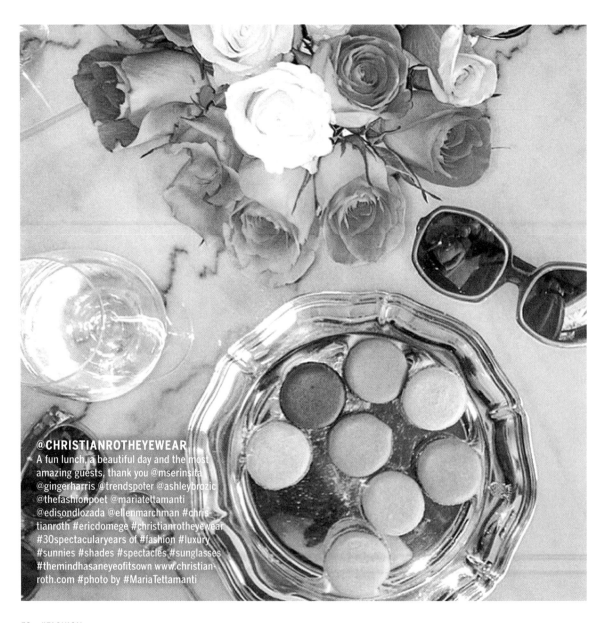

@CHRISTIANROTHEYEWEAR
A fun lunch, a beautiful day and the most
amazing guests, thank you @mserinsita
@gingerharris @trendspoter @ashleybrozic
@thefashionpoet @mariatettamanti
@edisondlozada @ellenmarchman #chris-
tianroth #ericdomege #christianrotheyewear
#30spectacularyears of #fashion #luxury
#sunnies #shades #spectacles #sunglasses
#themindhasaneyeofitsown www.christian-
roth.com #photo by #MariaTettamanti

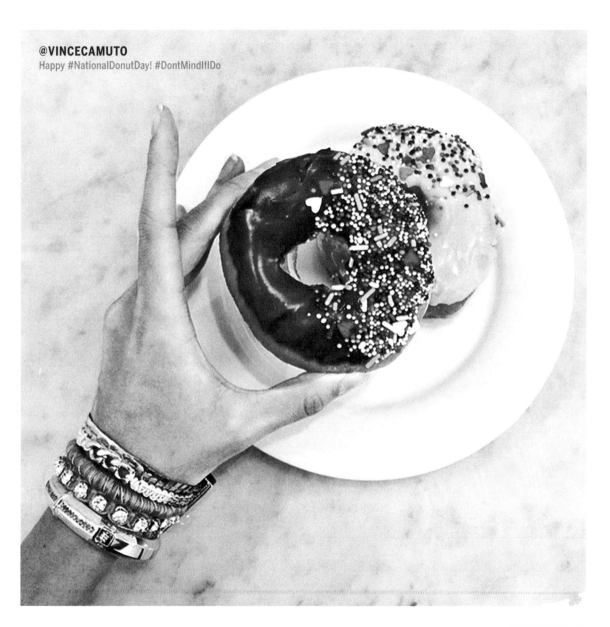

@PAIGENOVICK

@PAUL_MARLOW

@REEM_ACRA

@NANETTELEPORE

@TORYBURCH

@HENRIBENDEL

@SUESTEMP

@RODKEENANNEWYORK

@PETERSOM

@OVADIAANDSONS

@RICHARDLAMBERTSON

@CYNTHIAVINCENT

@DENNISBASSO

@EDUN

@SOPHIEBUHAI

@ULLAJOHNSON

@MONIQUEPEAN

@SLOWANDSTEADYWINSTHERACE

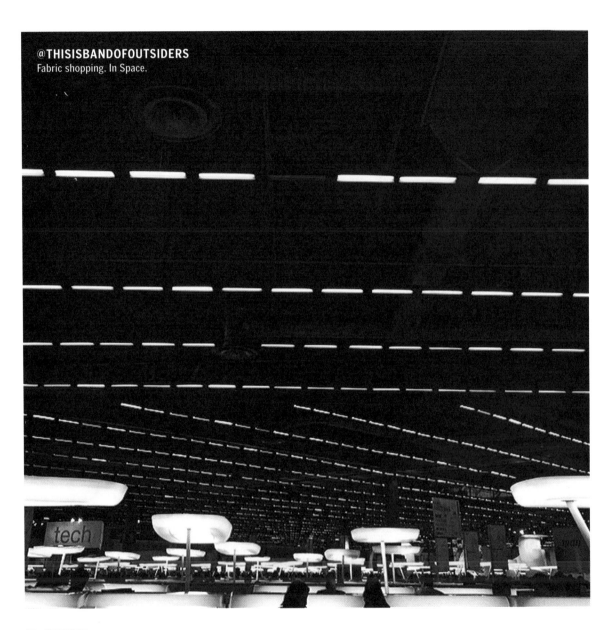

@THISISBANDOFOUTSIDERS
Fabric shopping. In Space.

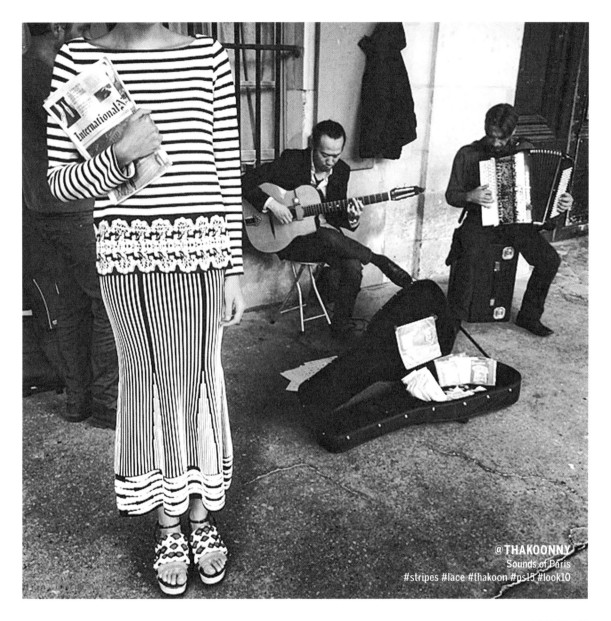

@**THAKOONNY**
Sounds of Paris
#stripes #lace #thakoon #ps15 #look10

@SALVATORECESARANI

@NAEEMKAHNNYC

@SHELLYSTEFFEE

@PAMELALOVENYC

@LISAPERRYSTYLE

@KFALCHI

@RODKEENANNEWYORK

@ALABAMACHANIN

@CATHYWATERMAN

@NICHOLASKSTUDIO

@MONIQUELHUILLIER

@SOPHIEBUHAI

@BCBGMAXAZRIA

@LORRAINESCHWARTZ

@OFFICIALRODARTE

@RAFENEWYORK

@LELA_ROSE

@OVADIAANDSONS

@**GERARDYOSCA**
A scoop of pistachio after the beach.
#nofilter #icecream

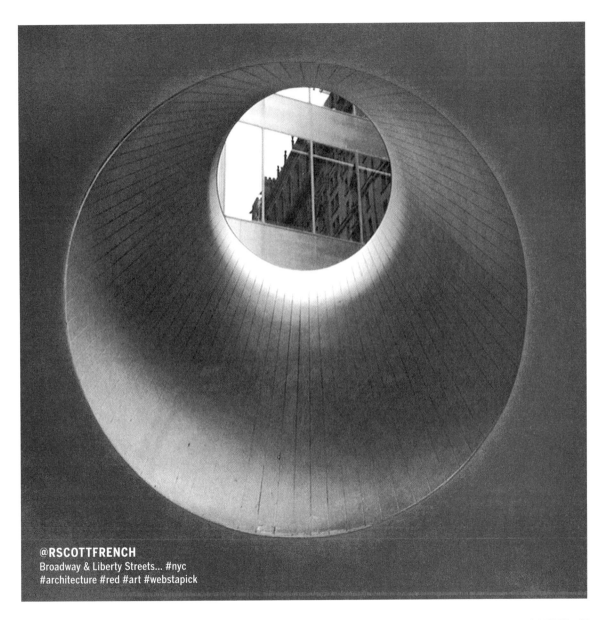

@RSCOTTFRENCH
Broadway & Liberty Streets... #nyc
#architecture #red #art #webstapick

@CFDA
All hands on deck backstage at
@thombrowneny. | by @aguynamedpatrick
#r29xcfda

@RALPHLAUREN

@PRABALGURUNG

@RALEIGHDENIMWORKSHOP

@TADASHISHOJI

#BEHIND THESEAMS

@ALBERTUS_SWANEPOEL

@ALEJANDROINGELMO

@JCOBANDO

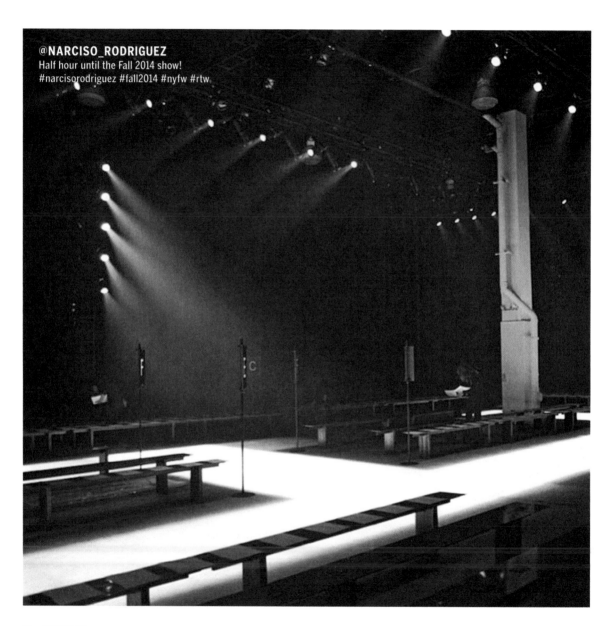

@NARCISO_RODRIGUEZ
Half hour until the Fall 2014 show!
#narcisorodriguez #fall2014 #nyfw #rtw

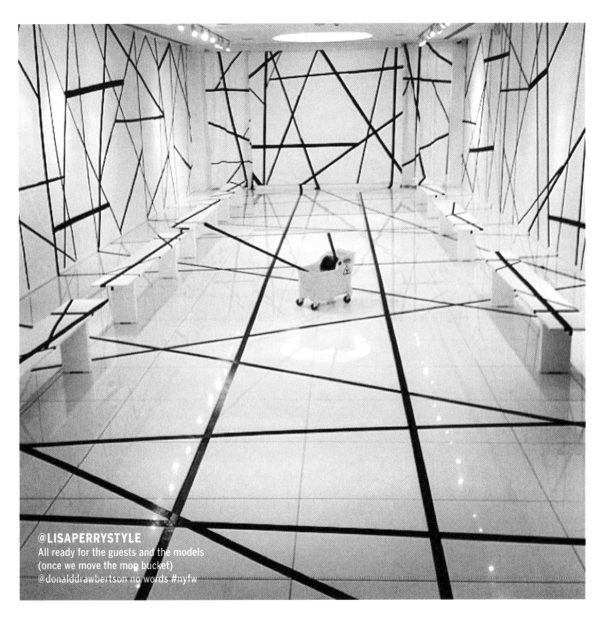

@LISAPERRYSTYLE
All ready for the guests and the models
(once we move the mop bucket)
@donalddrawbertson no words #nyfw

@BCBGMAXAZRIA

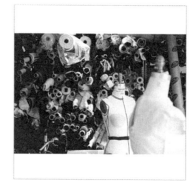

@BIBHUMOHAPATRA

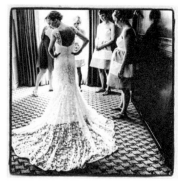

@LELA_ROSE

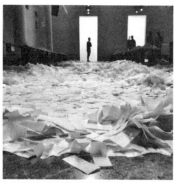

@PUBLICSCHOOLNYC

@HEISEL_CO

@MONIQUEPEAN

@ARIDEIN

@OVADIAANDSONS

@DEREKLAMNYC

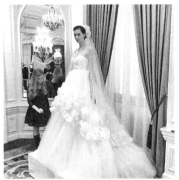

@GEORGINACHAPMANMARCHESA

@JACKIEROGERS000

@SOPHIETHEALLET

@TODDSNYDERNY

@GEMMAKAHNG

@CANDELANYC

@SKEARNEY73

@PETERSOM

@BILLY_REID

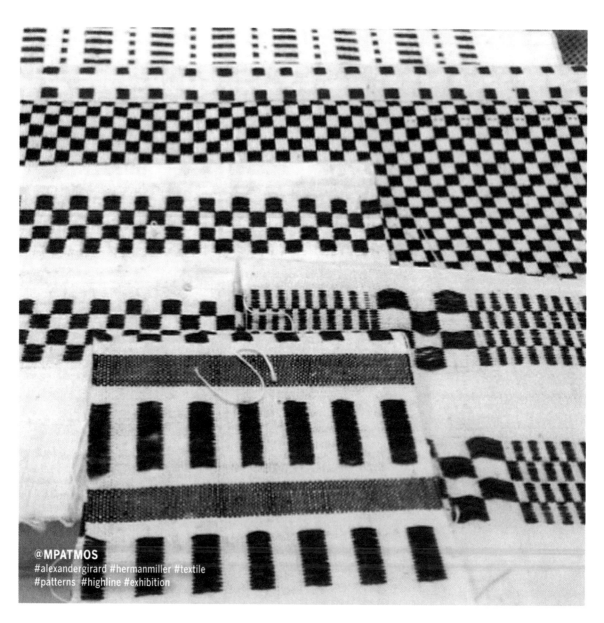

@MPATMOS
#alexandergirard #hermanmiller #textile
#patterns #highline #exhibition

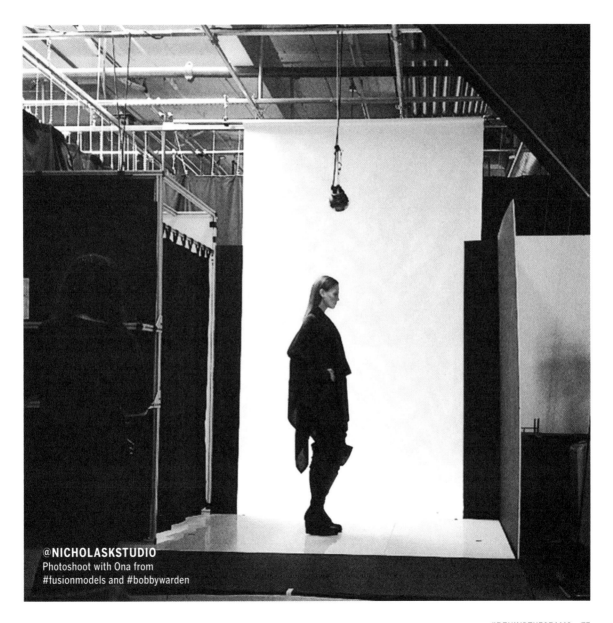

@**NICHOLASKSTUDIO**
Photoshoot with Ona from
#fusionmodels and #bobbywarden

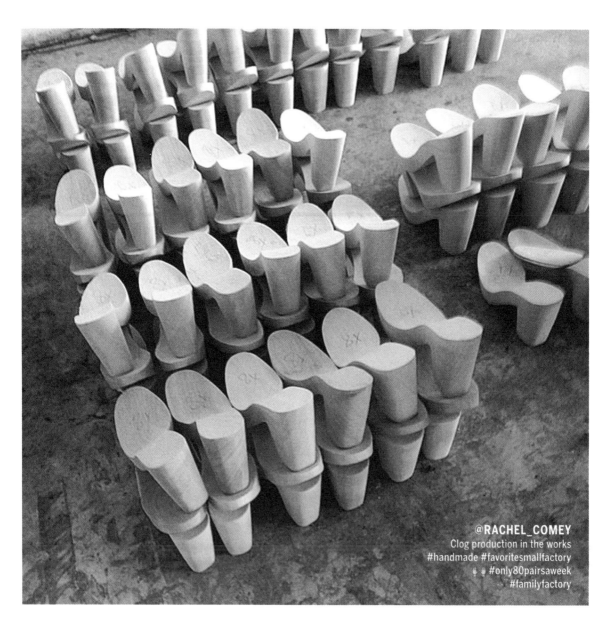

@RACHEL_COMEY
Clog production in the works
#handmade #favoritesmallfactory
👣 #only80pairsaweek
#familyfactory

@FALLONJEWELRY →
This is what I came home to. I smell trouble... like someone put a secret 💩 somewhere.

@JASONWU ↘
It's #NYFW prep time!! #jasonwu #spring2015

@IRENENEUWIRTH ↓
I can't take it

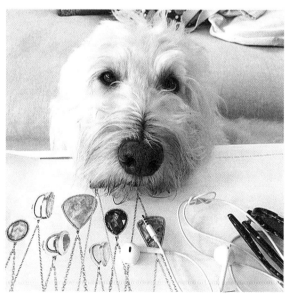

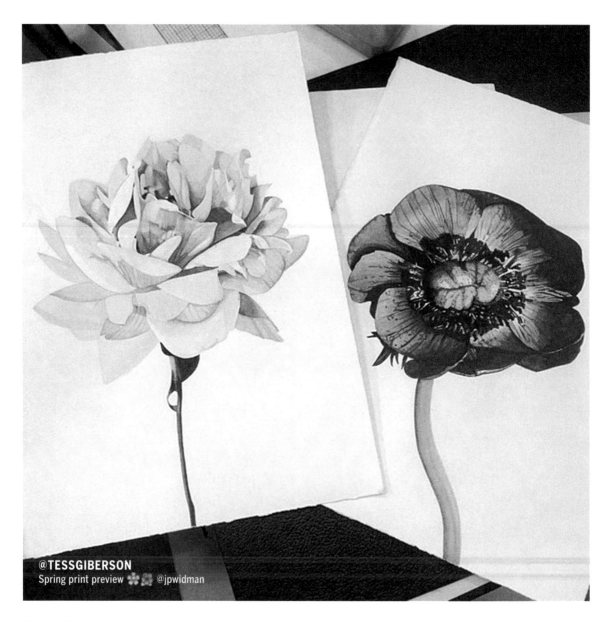

@TESSGIBERSON
Spring print preview 🌸🌺 @jpwidman

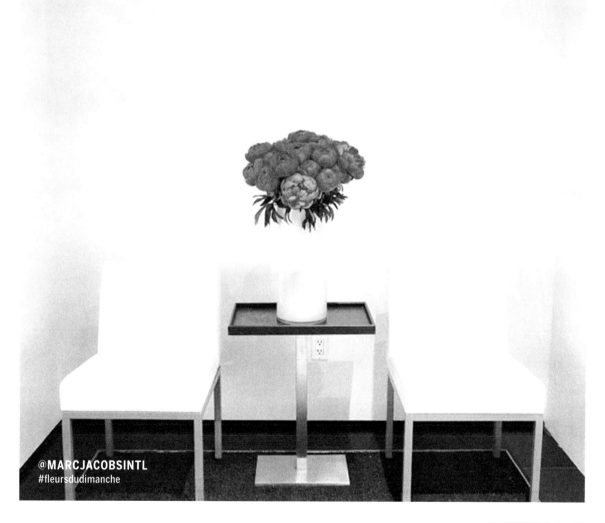

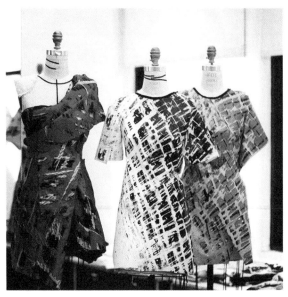

← **@GILLESMENDEL**
Two dresses made of paper and scotch tape on the right in preparation for embroideries, a red silk jacquard draped one on the left, all inspired from Enoc Perez amazing work. @enocperez #JMendel #OMGilles

↙ **@HOUSEOFHERRERA**
The tale of her show. #carolinaherrera @nytimesfashion #johnkoblin. Must read & see. #jenniferaltman photo.

↓ **@SULLYBONNELLY**
Color inspiration spring 2015 #color #spring2015

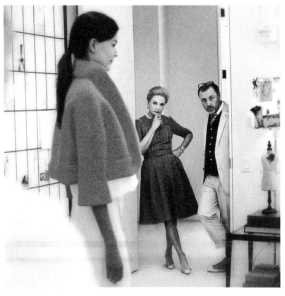

@ARIDEIN ↑
Smart like pajamas.

@KATESPADENY ↗
see you later work week. weekend
here we come!

@KARENHARMANINC →
Fall just can't come any sooner!
#karenharmaninc #fall2014 #nyc
#madeinamerica

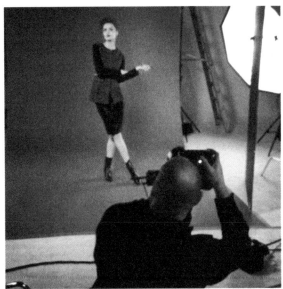

@THISISBANDOFOUTSIDERS
File by color.

↖ **@MARCALARY**
A Closer look on the Passerina Tee I made
for @jcrew Collaboration Find out more
at heck at http://jcrew.tumblr.com/
@cfda @voguemagazine #fashionfund

↑ **@OSCARPRGIRL**
love this @jennymwalton - that's my favorite
look on the left (@cfda 2 years ago) I can't
believe you remember it. thank you for this
picture. E

← **@CHARLOTTERONSON**
@charlotteronson + @vogueeyewear +
@cfda #designseries @sunglasshut #muse
@evamendes 😎 #charlotteronson
#evamendes #sunnies

@CHARLOTTERONSON

@ARAKS_YERAMYAN

@MONICARICHKOSANN

@CARLOSMIELEOFICIAL

@PAUL_MARLOW

@KAYUNGERDESIGN

@CSIRIANO

@BURKMANBROS

@MARCALARY

@ROBERTGELLER

@COSTELLOTAGLIAPIETRA

@ALEXANDREBIRMAN

@ANGELSANCHEZPR

@KEANANDUFFTY

@ANDREW_FEZZA

@PAIGENOVICK

@ME_CUTANDSEW

@DVF

@31PHILLIPLIM

@REEM_ACRA

@KERENCRAIGMARCHESA

@WHIT_NY

@ME_CUTANDSEW

@MICHAELKORS

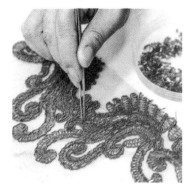

@TADASHISHOJI

@CYNTHIAVINCENT

@SOPHIEBUHAI

@BOTKIER

@JOHNVARVATOS

@CHOCHMAN1

@PETERSOM

@RAG_BONE

@OVADIAANDSONS

@BARTONPERREIRA

@ALICEANDOLIVIA

@VERAWANGGANG

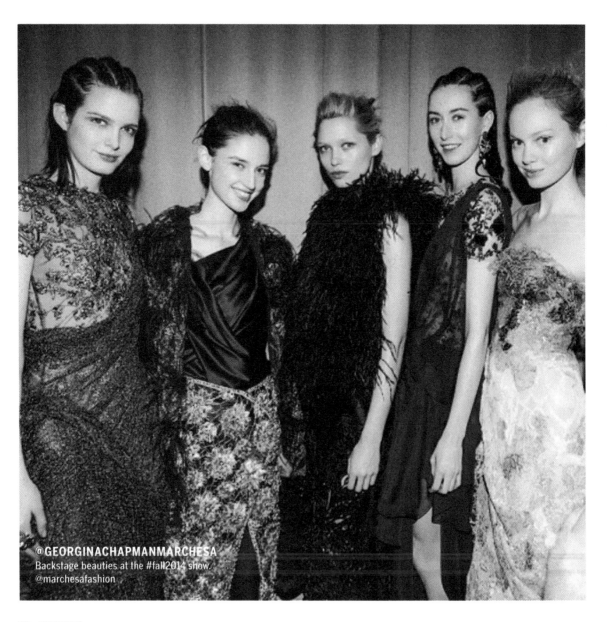

@GEORGINACHAPMANMARCHESA
Backstage beauties at the #fall2014 show.
@marchesafashion

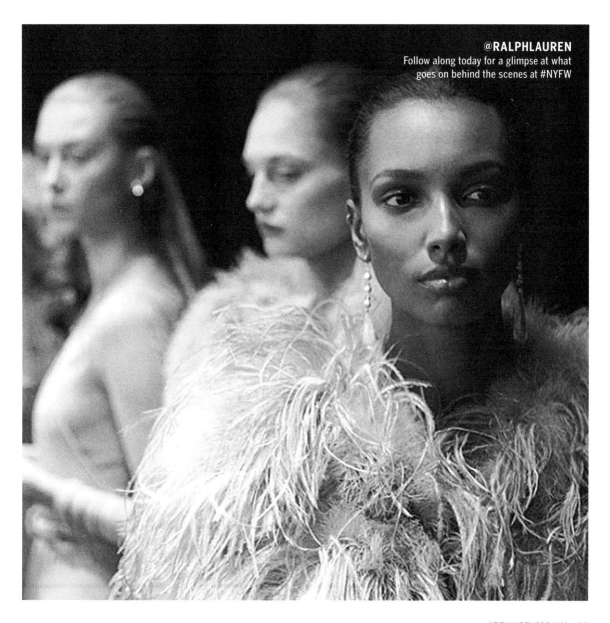

@RALPHLAUREN
Follow along today for a glimpse at what
goes on behind the scenes at #NYFW

@AMSALEBRIDAL

@ARAKS_YERAMYAN

@CHERESKINSTUDIO

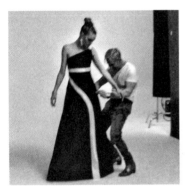

@DAVID_MEISTER

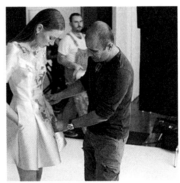

@SACHINANDBABI

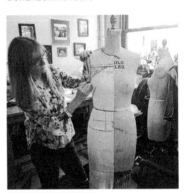

@NICOLEMILLERNYC

@TIBI

@RALEIGHDENIMWORKSHOP

@BILLY_REID

@GEMMAKAHNG

@JCOBANDO

@JASONWU

@MONIQUELHUILLIER

@SOPHIETHEALLET

@NARCISO_RODRIGUEZ

@MEANDROJEWELRY

@MIMISOJEWELS

@LISAJENKSJEWEL

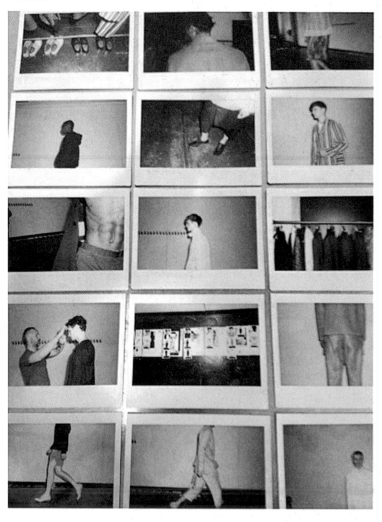

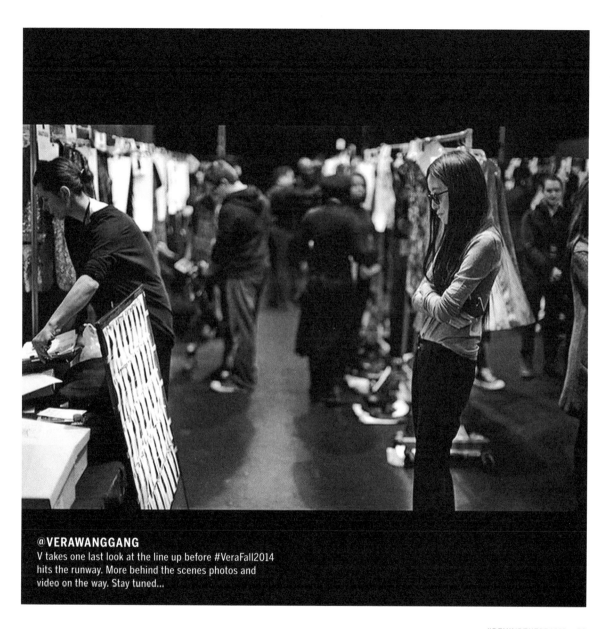

@VERAWANGGANG
V takes one last look at the line up before #VeraFall2014
hits the runway. More behind the scenes photos and
video on the way. Stay tuned...

@CHOCHMAN1

@RUFFIAN

@VANESSANOELSTYLE

@ALICEANDOLIVIA

@APOLIS

@JASONWU

@VERONICABEARD

@OVADIAANDSONS

@SALVATORECESARANI

@BIBHUMOHAPATRA

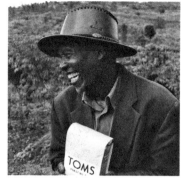

@TOMS

@ALEXISBITTAR

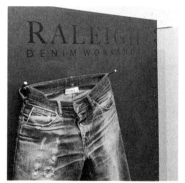

@RALEIGHDENIMWORKSHOP

@ME_CUTANDSEW

@ROBERTGELLER

@DEREKLAMNYC

@LUISFERN5

@TODDSYNDERNY

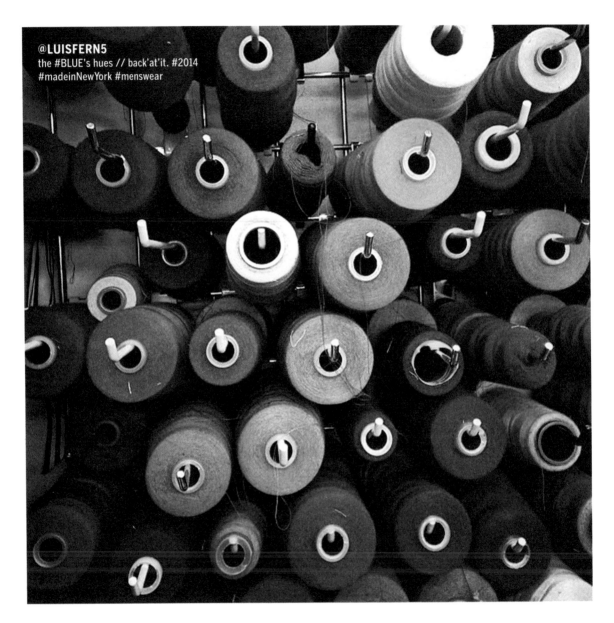

@**LUISFERN5**
the #BLUE's hues // back'at'it. #2014
#madeinNewYork #menswear

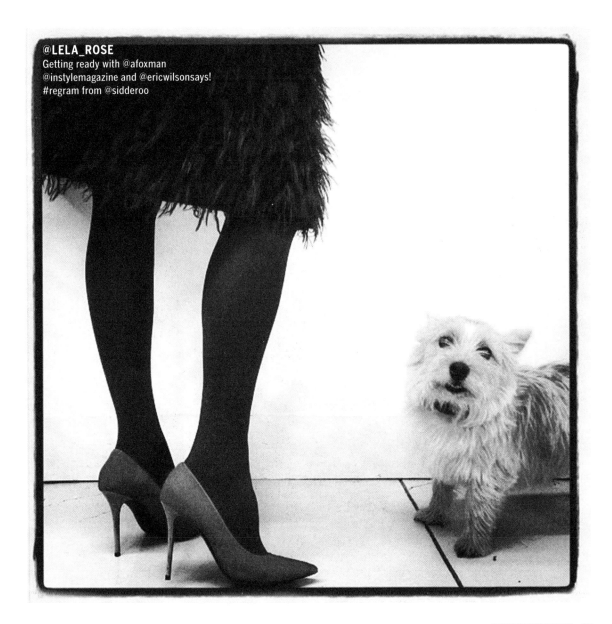

@**LELA_ROSE**
Getting ready with @afoxman
@instylemagazine and @ericwilsonsays!
#regram from @sidderoo

← **@MPATMOS**
#garmentdistrict #color #inspiration

↙ **@THAKOONNY**
Knits over knits FW14

↓ **@TABITHASIMMONS**
@caradelevingne flying suit - safe travels
back to UK darling!!!!

@THISISBANDOFOUTSIDERS →
File under #rainbow.

@VANESSANOELSTYLE ↘
My Translucent Alligator #cfda
#fashion #shoes

@TALBOTRUNHOF ↓
paris, paris mon amour!
#talbotrunhof #défilé14 #boutique
#paris #pictureframe #corduroy

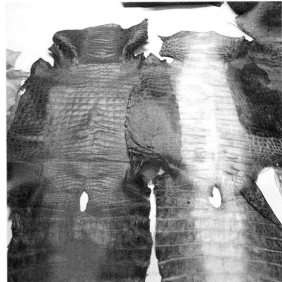

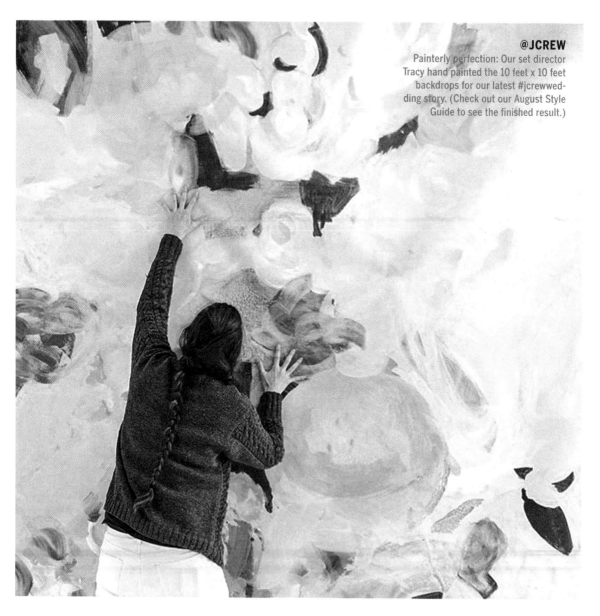

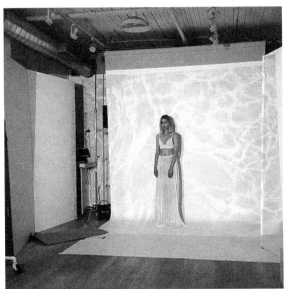

@TESSGIBERSON ↑
@charliepaille Resort 15!

@BCBGMAXAZRIA ↗
From one of my favorite shoots, no such thing
as too many flowers! 🌺🌷🌸🌹

@MELISSAJOYMANNING →
New at #12wooster #mjmnyc - appraisal
services!! Our resident expert is happy to
help. #JK #themonks

@CALVINKLEIN ↑
Global Creative Director Kevin Carrigan.
#calvinkleinlive from Singapore
The setting.

@RACHEL_ROY ↗
Shooting a Levi's #NYFW campaign 😳
nice distraction from workin
on the collection 😱🤍👄👄

@EDUN →
Danielle Sherman featured in The NY Times,
Fashion in the Age of Instagram
@nytimesfashion @matthewschneier

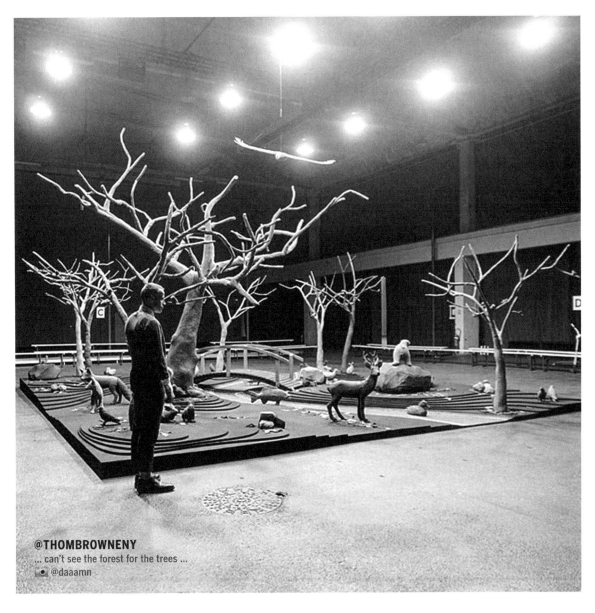

@THOMBROWNENY
... can't see the forest for the trees ...
📷 @daaamn

@RACHEL_COMEY

@DENNISBASSO

@SELIMAOPTIQUE

@ASSEMBLYNEWYORK

@NICHOLASKSTUDIO

@ERICKSONBEAMONOFFICIAL

@RAFENEWYORK

@RUFFIAN

@ARIDEIN

@TADASHISHOJI

@LISAPERRYSTYLE

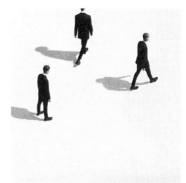

@TITLEOFWORK

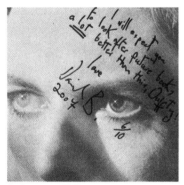

@KEANANDUFFTY

@SLOWANDSTEADYWINSTHERACE

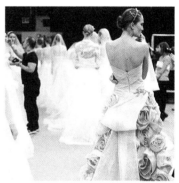

@MONIQUELHUILLIER

@DVF

@MONICARICHKOSANN

@THISISBANDOFOUTSIDERS

@MARCJACOBSINTL
Who wants to go shopping?
Get your #FW13 favorites
marcjacobs.com

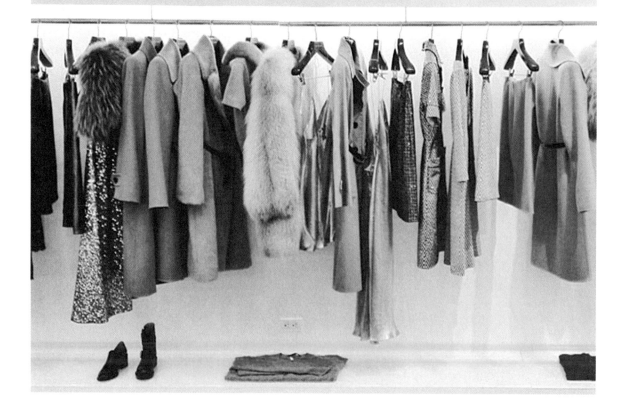

@APOLIS →

On Thursday, May 8th, we will be releasing a short film documenting the inspirational process from origin in Ethiopia to retail at the @AceHotel. Take a look at the behind-the-scenes photostory on the Apolis Journal. If you're looking for a last minute gift for Mother's Day (May 11th), take advantage of the Free 2-Day Shipping for ALL Domestic Orders, with check out code MOTHERS2014. LAST DAY Expedited shipping savings is valid through TODAY, May 6th.

@ALEJANDROINGELMO ↘

And she calls herself the boss?! @cece_bennett #alejandroingelmo#boomerang

@GEORGINACHAPMANMARCHESA ↓

On set. @marchesafashion #spring2014

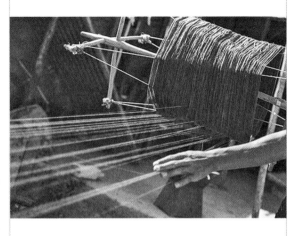

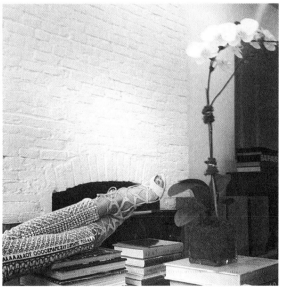

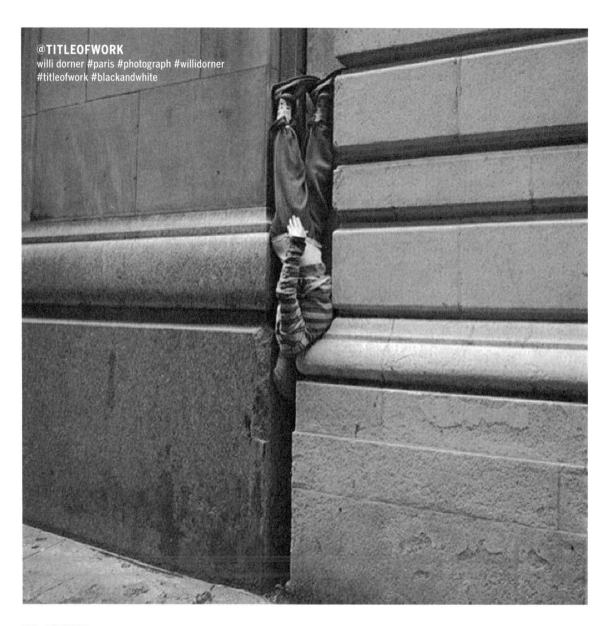

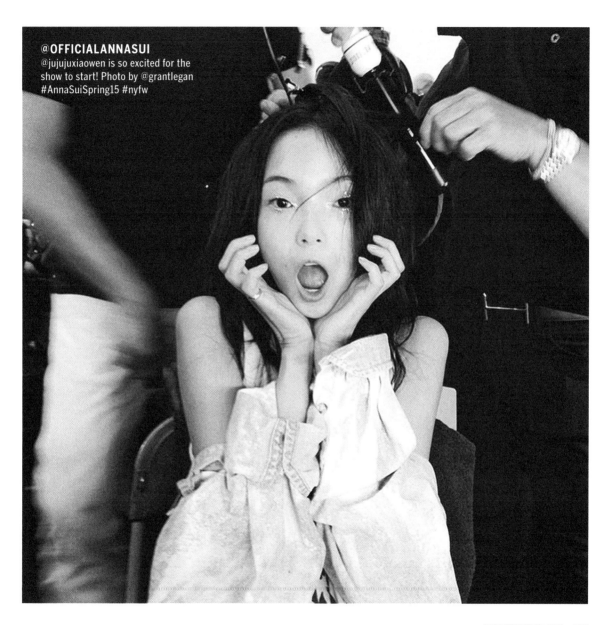

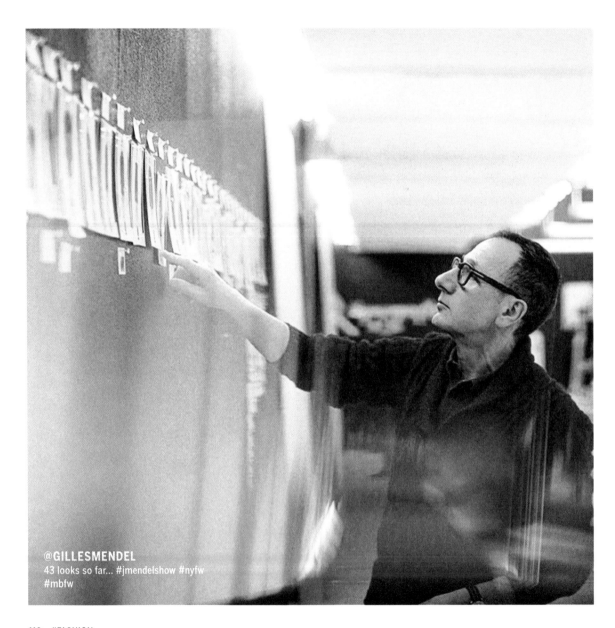

@GILLESMENDEL
43 looks so far... #jmendelshow #nyfw
#mbfw

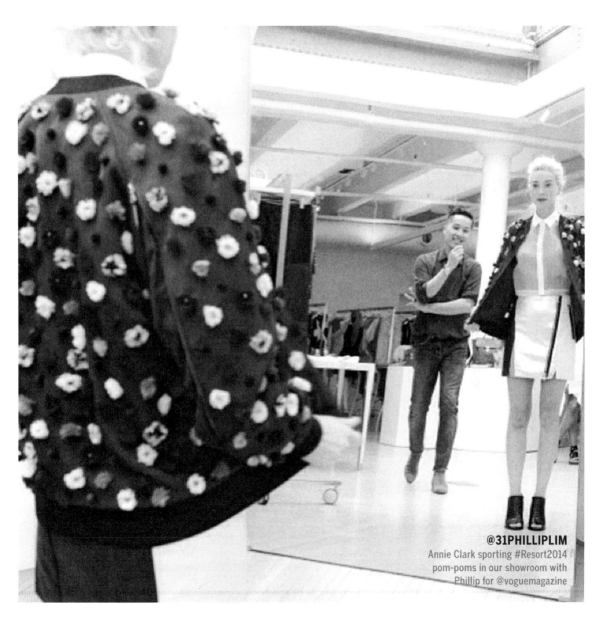

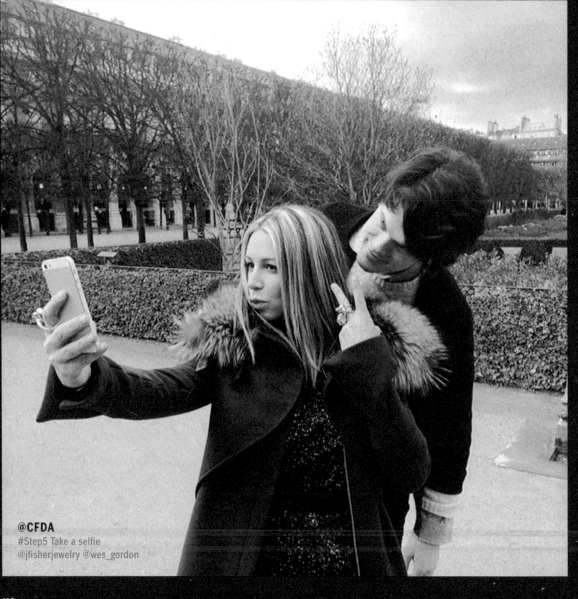

@CFDA
#Step5 Take a selfie
@jfisherjewelry @wes_gordon

@GGUBLO67

@RACHEL_ROY

@VANESSANOELSTYLE

@CHARLOTTERONSON

#SELFIES

@RUFFIAN

@OFFICIALLIBERTINE

@COLETTEMALOUF

@BURKMANBROS

Pensamiento. @_digdoug sporting @BurkmanBros'
Spring/Summer 2015 hoodie. Coming soon! #ss15
#CapsuleShowNYC #PeoplesAura #MakePortraits
#burkman #love #portraits #friends #instaphoto
#makeawesomeclothes #photo #thatnewnow #light
#peoplesaura #instagood #ny #latergramsforever
#sun #fun #nyc #potd #instamood #makeportraits

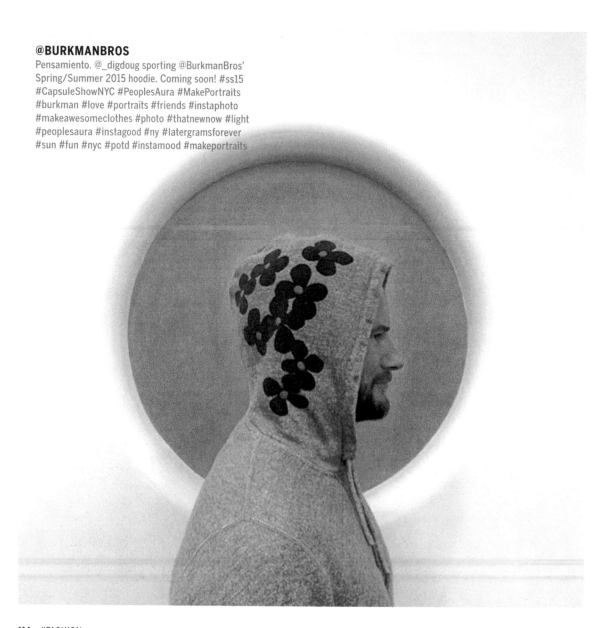

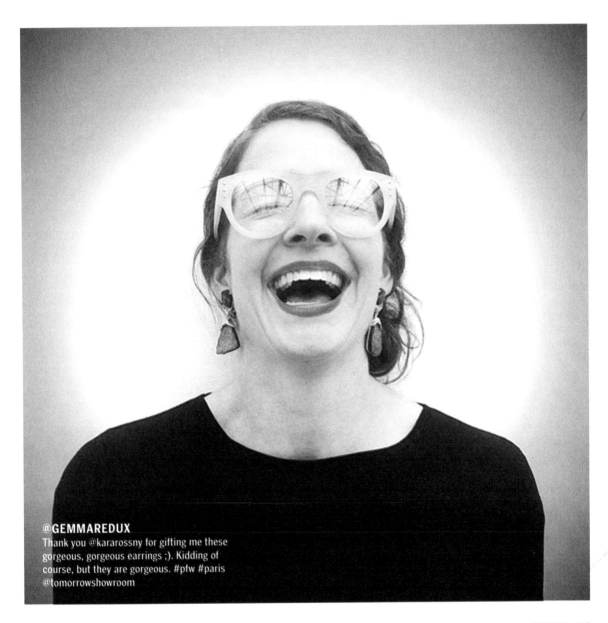

@GEMMAREDUX
Thank you @kararossny for gifting me these
gorgeous, gorgeous earrings ;). Kidding of
course, but they are gorgeous. #pfw #paris
@tomorrowshowroom

@ITALOZUCCHELLI

@KARAROSSNY

@MATTMURPHYNYC

@ALABAMACHANIN

@JOHNBARTLETT8

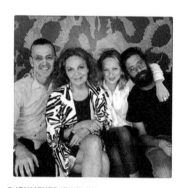

@JENMEYERJEWELRY

@SKEARNEY73

@THAKOONNY

@IRENENEUWIRTH

@REBECCATAYLORNYC

@SULLYBONNELLY

@GERARDYOSCA

@GIULIETTANEWYORK

@PAMELALOVENYC

@OFFICIALLIBERTINE

@SOPHIEBUHAI

@LUISFERN5

@VSA_DESIGNS

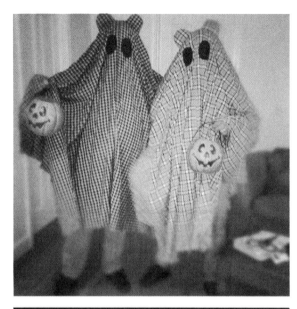

← **@COSTELLOTAGLIAPIETRA**
spookybears stuck in ptown

↙ **@PETERSOM**
A day on the water @momentsailingadventures #momentsailing ph. @tilbury #nycharbor #sunday

↓ **@MARAHOFFMAN**
Vacation Levitation... #oceanedition

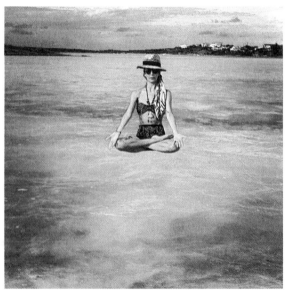

@JASONWU →
Seaside 🏖️

@LOREERODKIN ↘
Greece / boat life

@HOUSEOFLAFAYETTE ↓
House of Lafayette hats in Gaeta #hol
#houseoflafayette #holidays #hats #friends
#gaeta #italy #fun #sea #sun #summer
@houseoflafayette

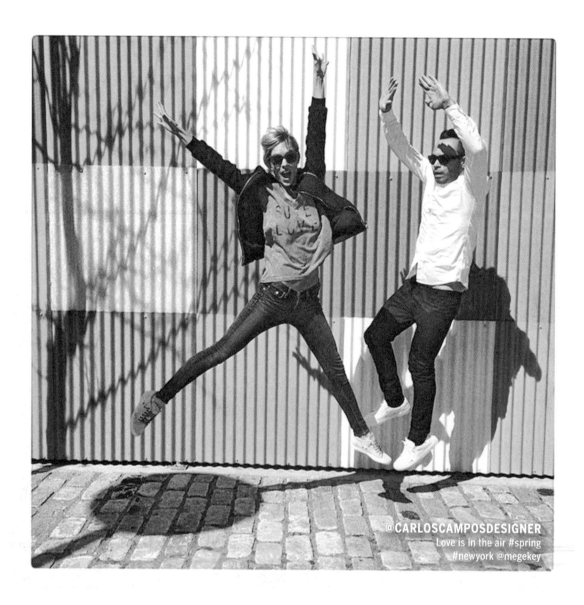

@CARLOSCAMPOSDESIGNER
Love is in the air #spring
#newyork @megekey

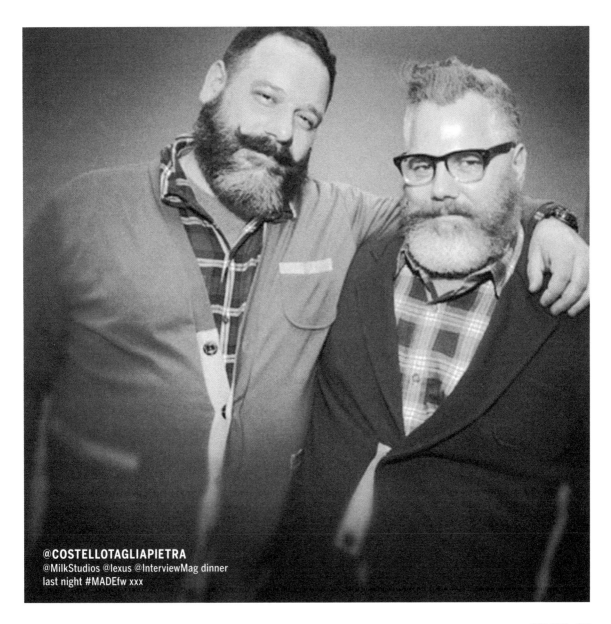

@COSTELLOTAGLIAPIETRA
@MilkStudios @lexus @InterviewMag dinner
last night #MADEfw xxx

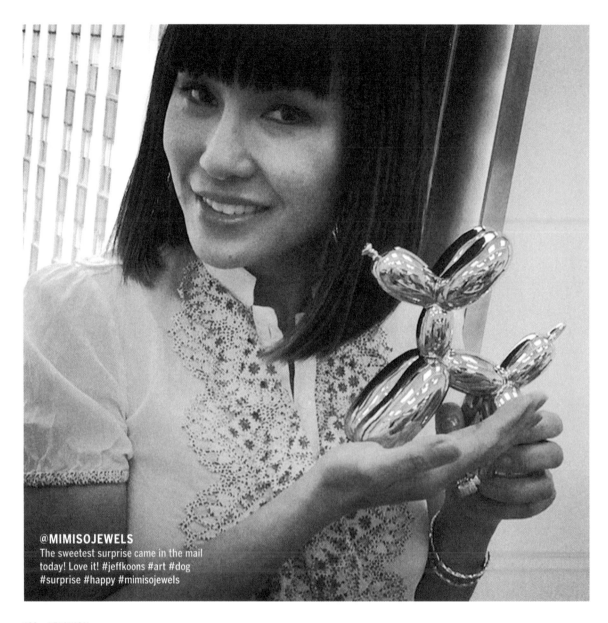

@MIMISOJEWELS
The sweetest surprise came in the mail
today! Love it! #jeffkoons #art #dog
#surprise #happy #mimisojewels

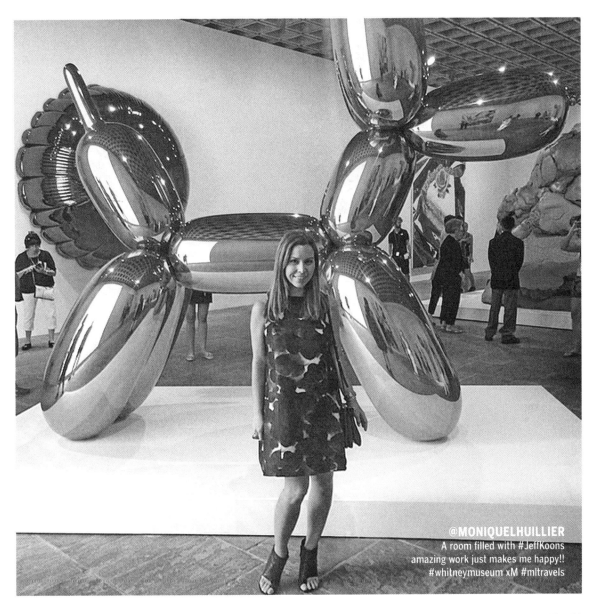

@MONIQUELHUILLIER
A room filled with #JeffKoons
amazing work just makes me happy!!
#whitneymuseum xM #mltravels

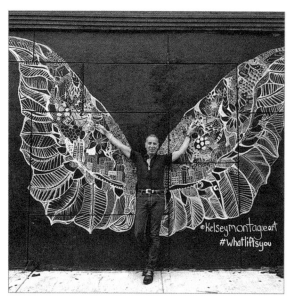

← **@STEPHENDWECK**
After a hard days work I can just fly to the moon! I really love my JOB!! #whatliftsyou @kelseymontagueart

↙ **@TABITHASIMMONS**
#VictoriaSecret after party! With the beautiful @lilyaldridge and yes I am in a ball gown!!!

↓ **@ERINFETHERSTON**

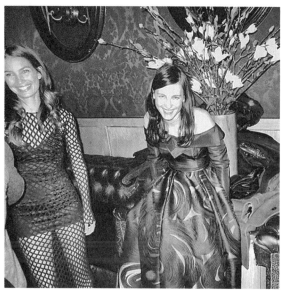

↖ **@THEELDERSTATESMANOFFICIAL**
Best conversation I've had all day
#janeandserge #giantteddybear
#theelderstatesman

↑ **@KERENCRAIGMARCHESA**
#fbf me and my BFF @geOrginachapman
@marchesafashion #marchesa
#dressingupisfun

← **@CYNTHIA_ROWLEY**
@lindseyvonn did a last-minute alteration
to my dress for the White House Correspon-
dents' Dinner after-party. My room at
@stregishotels ended up looking like
someone had a pillow fight in it! Feathers
everywhere! #latergram #whcd #oops
#style #alterations #fashion

@CHRISTIANROTHEYEWEAR

@NATORICOMPANY

@ULRICHCPS

@PUBLICSCHOOLNYC

@VITAFEDE

@THAKOONNY

@RAFENEWYORK

@TADASHISHOJI

@RUTHIE_DAVIS

@TRACY_REESE

@cfda and @tide sure know how to pick a venue! Great view of #NYC from the @Mondrian for the washable fashion initiative panel

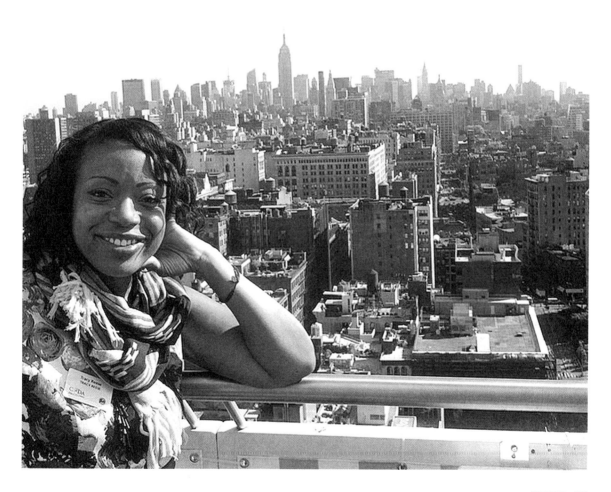

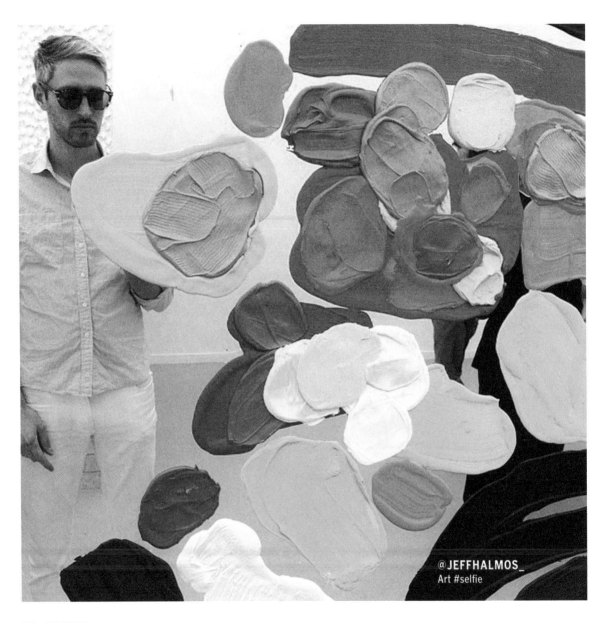

@JEFFHALMOS_
Art #selfie

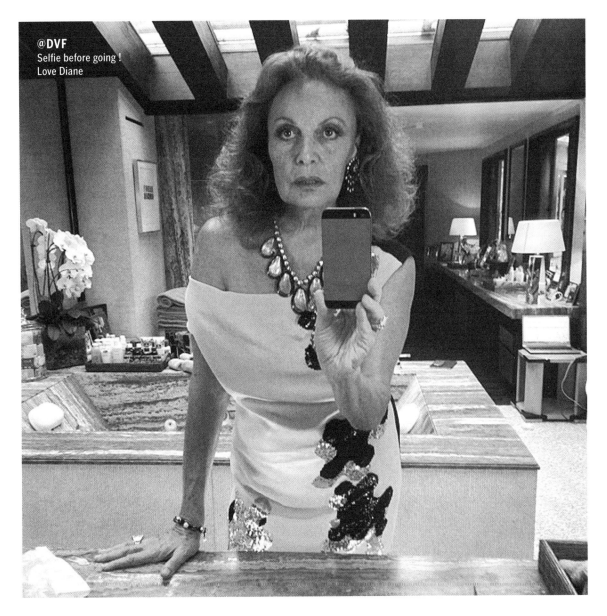

@**DVF**
Selfie before going !
Love Diane

@COOMIJEWELS

@SULLYBONNELLY

@PRABALGURUNG

@SAM_EDELMAN

@VERONICABEARD

@RACHEL_ROY

@OSCARPRGIRL

@BCBGMAXAZRIA

@ERINFETHERSTON

@JUSSARALEE

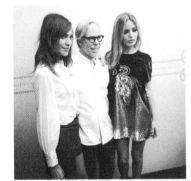

@TOMMYHILFIGER

@RACHELZOE

@TRINATURK

@ZEROMCORNEJO

@RICHARDLAMBERTSON

@CYNTHIAVINCENT

@ROBERTGELLER

@MIMISOJEWELS

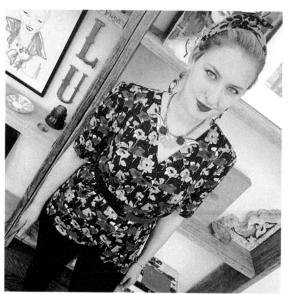

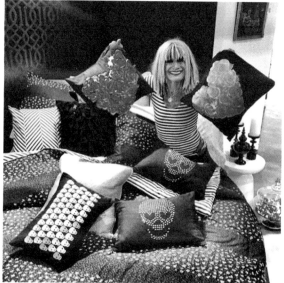

@LULU_FROST ↑
Lisa #wrappedinlulu wearing our Capri
headwrap and a new #vintage necklace -
ready for a packed day at the studio!

@XOBETSEYJOHNSON ↗
Sweet dreams babes! My new bedding
collection is almost here! 💋 💕 z z^Z

@KERENCRAIGMARCHESA →
Beijing day 1. #marchesavoyage sneak peek!
@marchesafashion

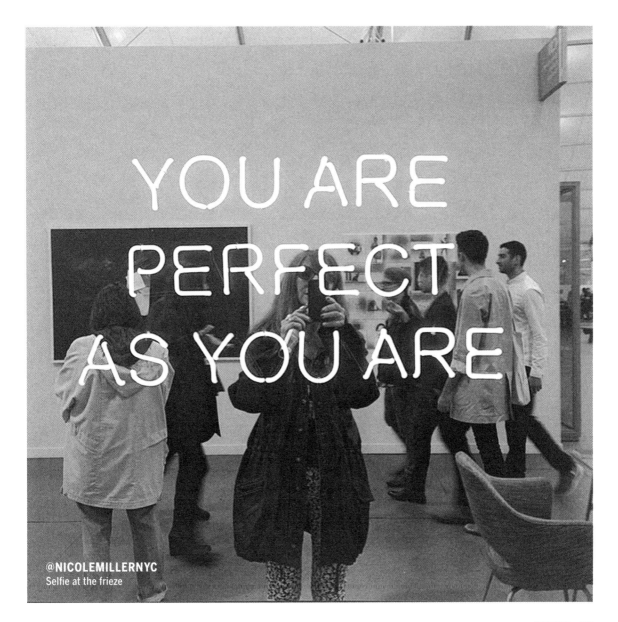

YOU ARE
PERFECT
AS YOU ARE

@NICOLEMILLERNYC
Selfie at the frieze

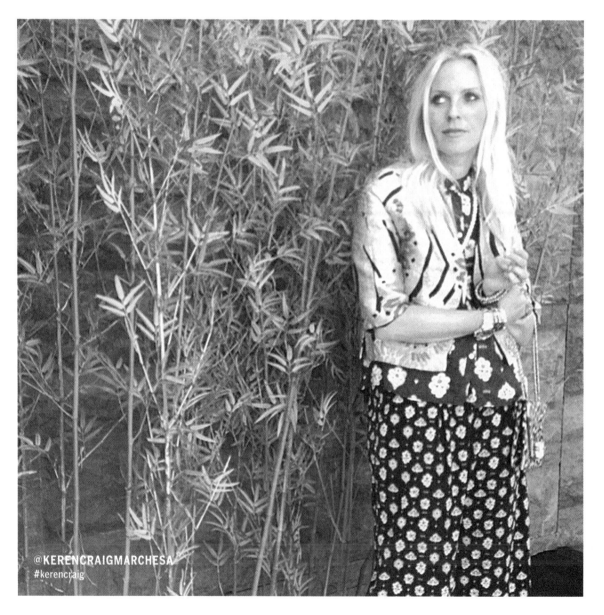

@**KERENCRAIGMARCHESA**
#kerencraig

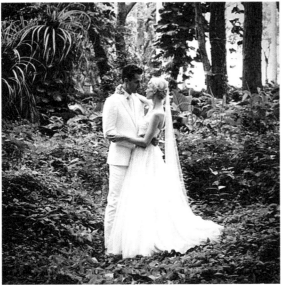

↖ **@LELA_ROSE**
No Hat Luncheon is complete without a ride
in the sidecar! (regram from @amandalou01)

↑ **@RACHEL_ROY**
We 🖤 u! Or maybe my lil one is 😩??
Either way happy happy joy joy weekend!!!
@jppierce3 #lisa #brandi 😵😷😷

← **@ERINFETHERSTON**
A scene from our wedding on the lush
grounds of St Nicholas Abbey
@gabrielsaporta @martha_weddings
@lmdfloral @frenchboy101

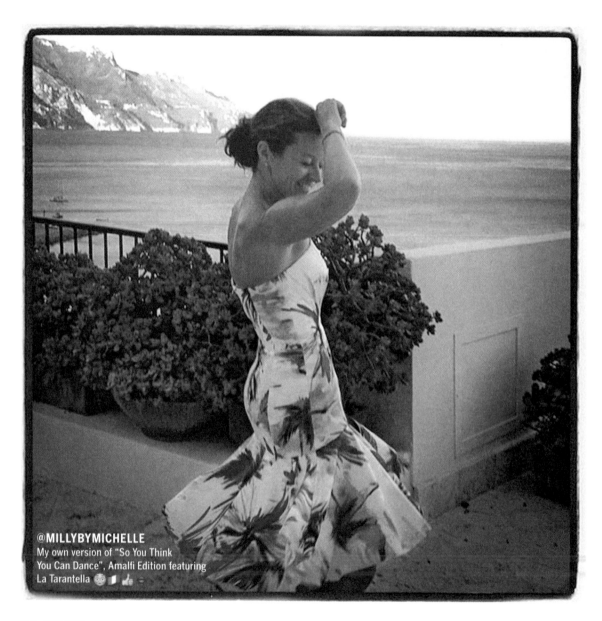

@MILLYBYMICHELLE
My own version of "So You Think
You Can Dance", Amalfi Edition featuring
La Tarantella 🎡📱🏩 ➖

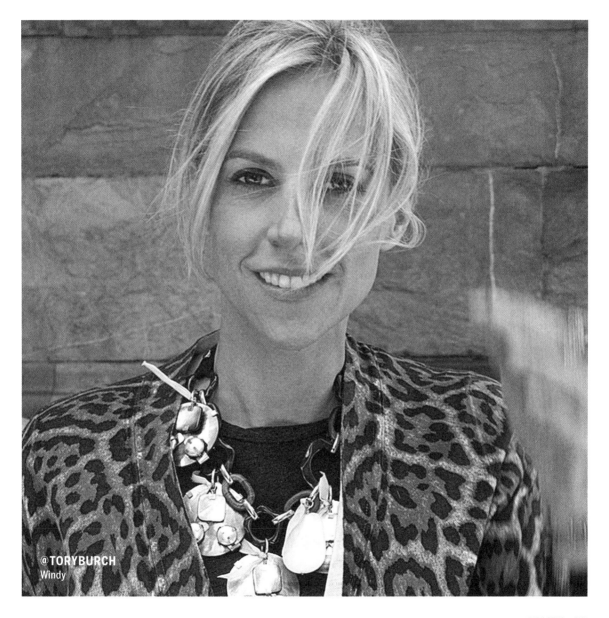

@TORYBURCH
Windy

↖ **@PAMELALOVENYC**
One more from my fashion week tips on
@mercedesbenz because I love this hat and
@narnia_vintage 🖤🖤🖤🚗🚗🚗

↑ **@SOPHIEBUHAI**
LA Sunday

← **@GEMMAKAHNG**
Good morning gorgeous! #nyc #inspiration
#industrialdesign #mechanix

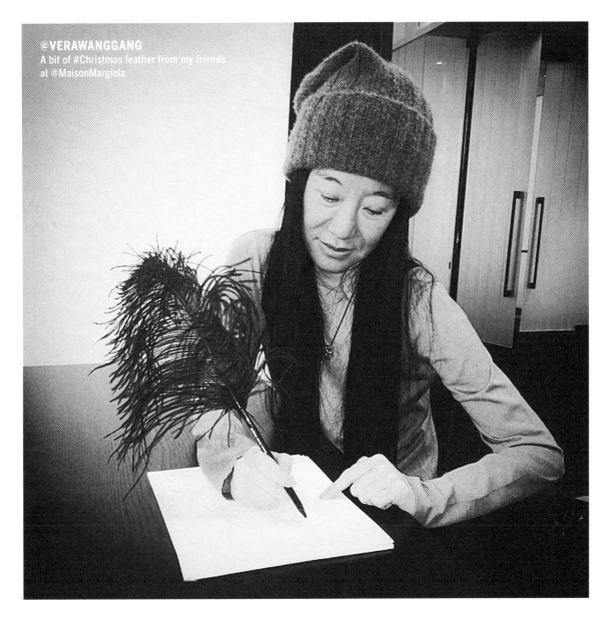

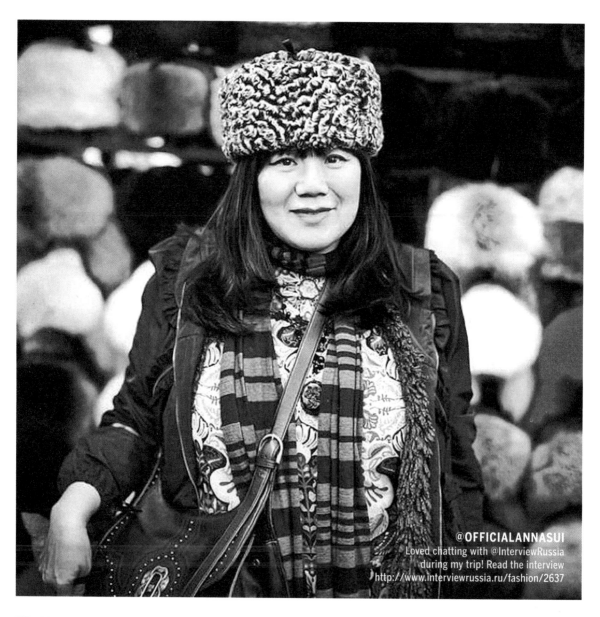

@OFFICIALANNASUI
Loved chatting with @InterviewRussia
during my trip! Read the interview
http://www.interviewrussia.ru/fashion/2637

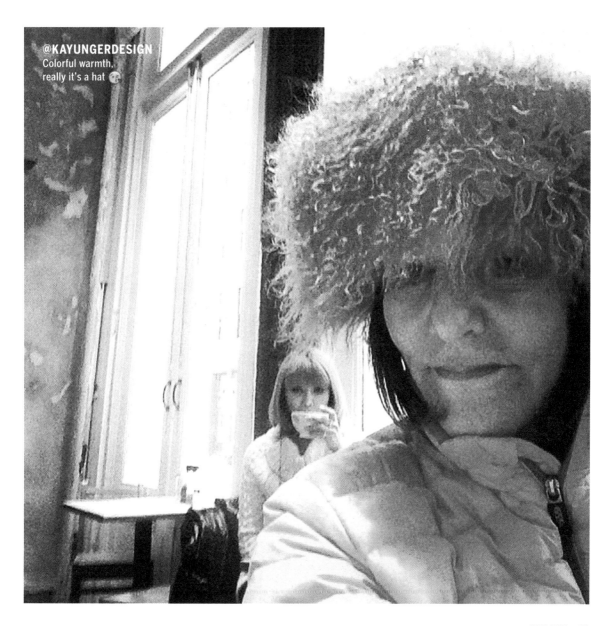

@KAYUNGERDESIGN
Colorful warmth,
really it's a hat 😳

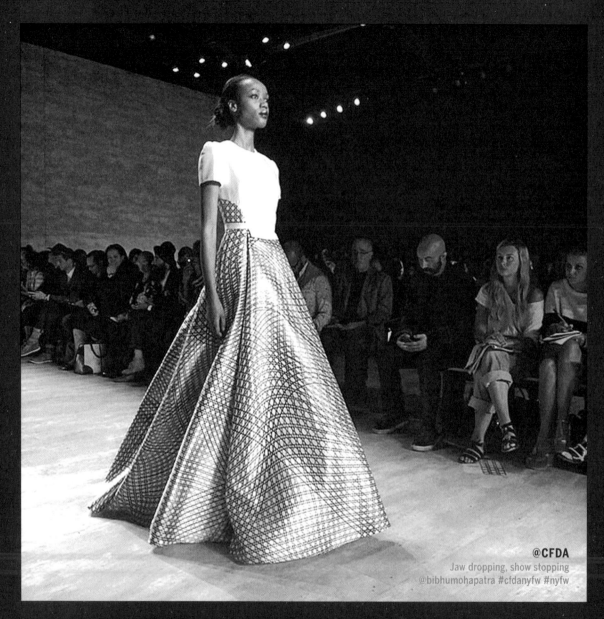

@CFDA
Jaw dropping, show stopping
@bibhumohapatra #cfdanyfw #nyfw

@THOMBROWNENY

@TITLEOFWORK

@HATUNDERWOOD

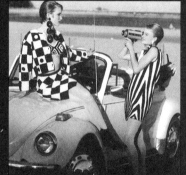

@__MICHAELSIMON

#FASHION

@AMOURVERT

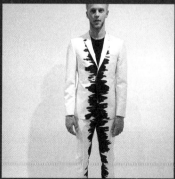

@ITALOZUCCHELLI

@SKEARNEY73

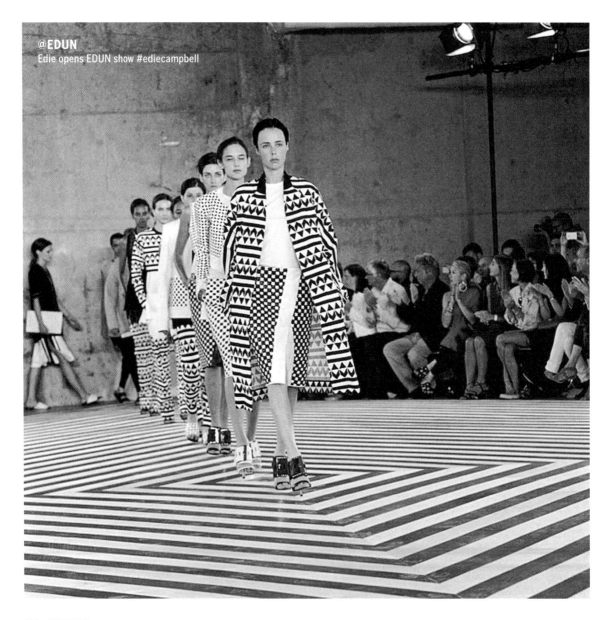

@**EDUN**
Edie opens EDUN show #ediecampbell

@DEREKLAMNYC ↑
Spotted @styledotcommarina of @styledotcom on the go in our straight-legged pant. Pic by @altamiranyc #SheWearsThePants

@REGINAKRAVITZCO ↗
#Faye jumpsuit

@PUBLICSCHOOLNYC →
Double tap if you're still finding confetti in your apartment, car, shoes, hair, and underwear from last nite's after party. #PSNYFW

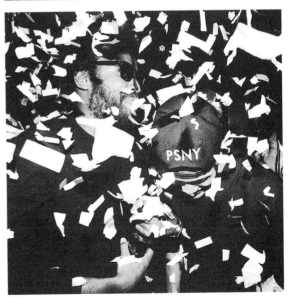

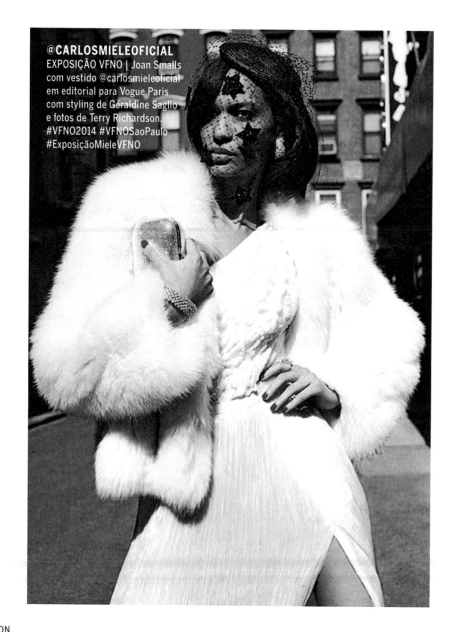

@**CARLOSMIELEOFICIAL**
EXPOSIÇÃO VFNO | Joan Smalls
com vestido @carlosmieleoficial
em editorial para Vogue Paris
com styling de Géraldine Saglio
e fotos de Terry Richardson.
#VFNO2014 #VFNOSaoPaulo
#ExposiçãoMieleVFNO

↖ **@REBECCATAYLORNYC**
Dreaming of Spring #RTspring2014
#springstyle

↑ **@ALABAMACHANIN**
Coming attractions...

← **@CARLOSCAMPOSDESIGNER**
Backstage FALL14 #nyfw regram
@rasmushaag much love

@JCOBANDO

@KEANANDUFFTY

@TABITHASIMMONS

@KARENHARMANINC

@DIESELBLACKGOLD

@RAG_BONE

@TESSGIBERSON

@CHROMEHEARTSOFFICIAL

@CHARLOTTERONSON

@AMSALEBRIDAL

@CARLOSCAMPOSDESIGNER

@VPLNYC

@HOUSEOFLAFAYETTE

"I HATE WHEN A WOMAN SAYS SHE'S 45 AS IF IT'S A BAD THING."

- ALEXIS BITTAR

@ALEXISBITTAR

@ALABAMACHANIN

@DEREKLAMNYC

@LUISFERN5

@KFALCHI

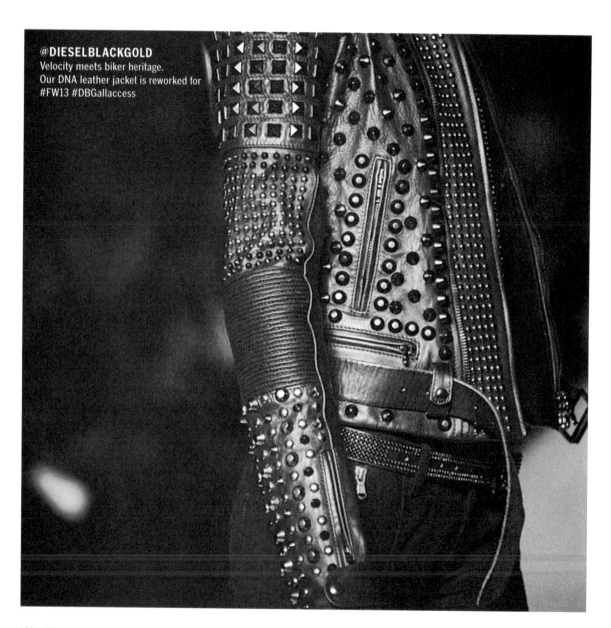

@**DIESELBLACKGOLD**
Velocity meets biker heritage.
Our DNA leather jacket is reworked for
#FW13 #DBGallaccess

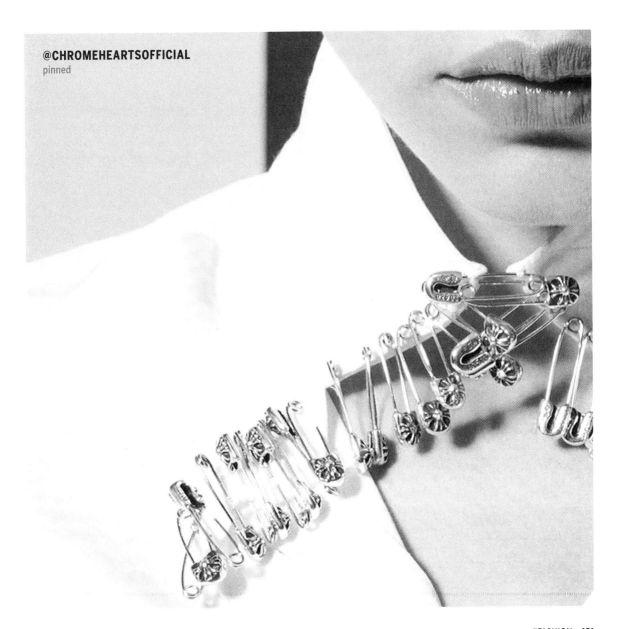

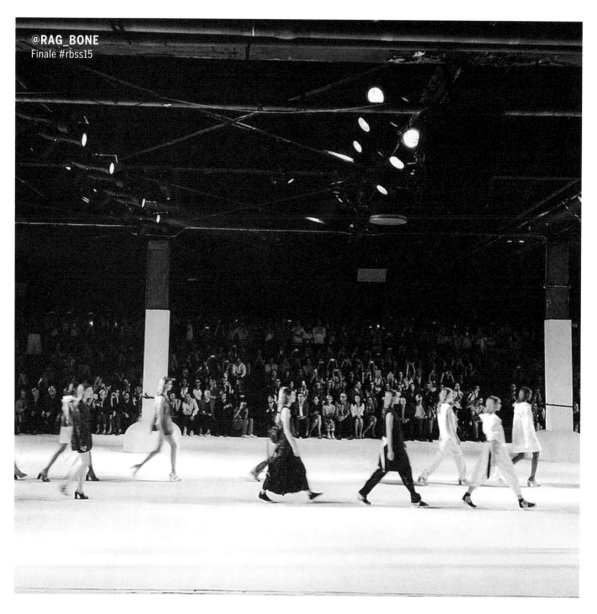

@RAG_BONE
Finale #rbss15

@DIESELBLACKGOLD

@NAEEMKAHNNYC

@VERAWANGGANG

@AMSALEBRIDAL

@OSCARPRGIRL

@ROBERTGELLER

@RODKEENANNEWYORK

@RSCOTTFRENCH

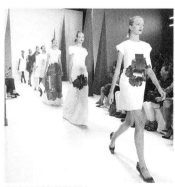

@HOUSEOFHERRERA

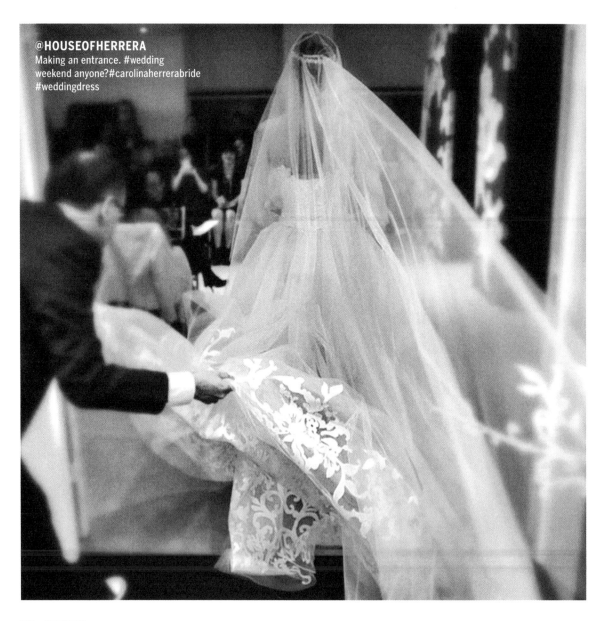

@HOUSEOFHERRERA
Making an entrance. #wedding
weekend anyone?#carolinaherrerabride
#weddingdress

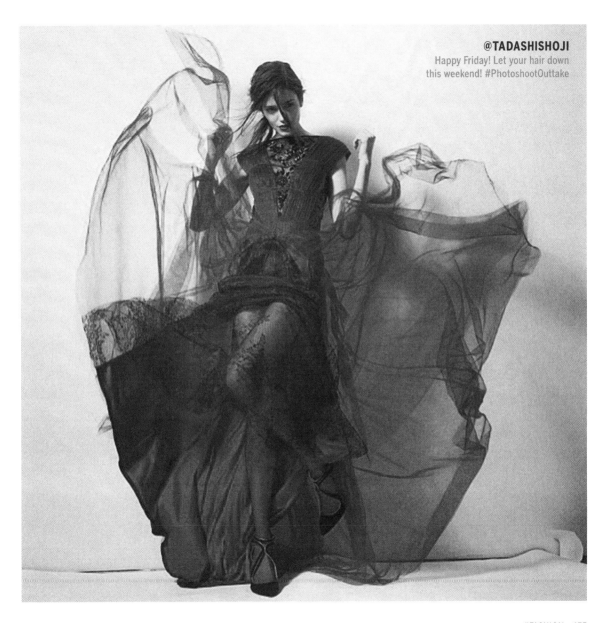

@XOBETSEYJOHNSON

@TRINATURK

@LAURAPORETZKY

@HENRIBENDEL

@SELIMAOPTIQUE

@VSA_DESIGNS

@SLOWANDSTEADYWINSTHERACE

@__MICHAELSIMON

@ERICACOURTNEYJEWELRY

@ERICJAVITS

@ASSEMBLYNEWYORK

@DIESELBLACKGOLD

@COSTELLOTAGLIAPIETRA

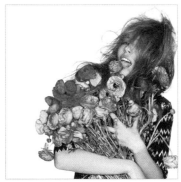

@CYNTHIA_ROWLEY

@MARAHOFFMAN

@ASHLEYPITTMANCO

@JOHNBARTLETT8

@CSIRIANO

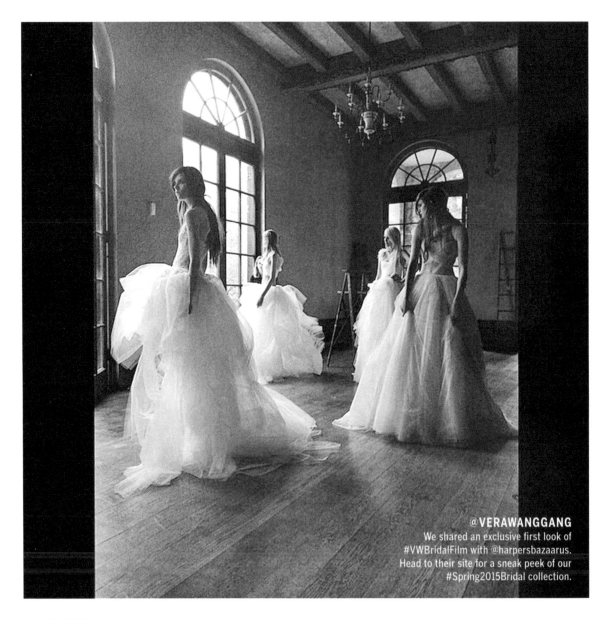

@VERAWANGGANG
We shared an exclusive first look of
#VWBridalFilm with @harpersbazaarus.
Head to their site for a sneak peek of our
#Spring2015Bridal collection.

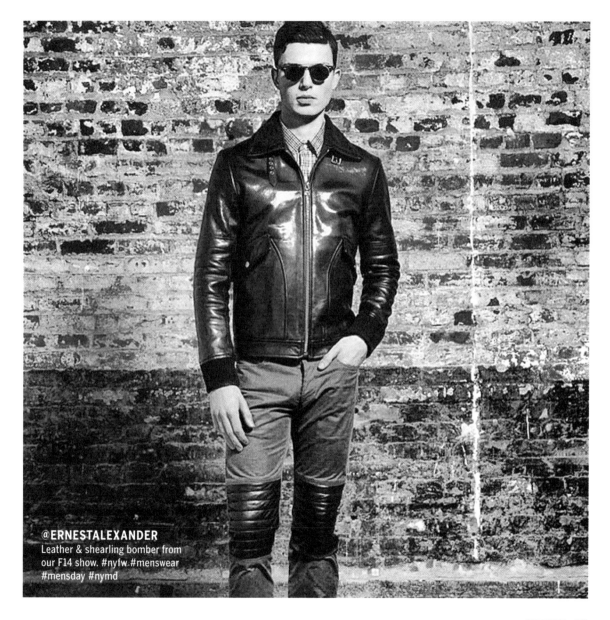

@ERNESTALEXANDER
Leather & shearling bomber from
our F14 show. #nyfw #menswear
#mensday #nymd

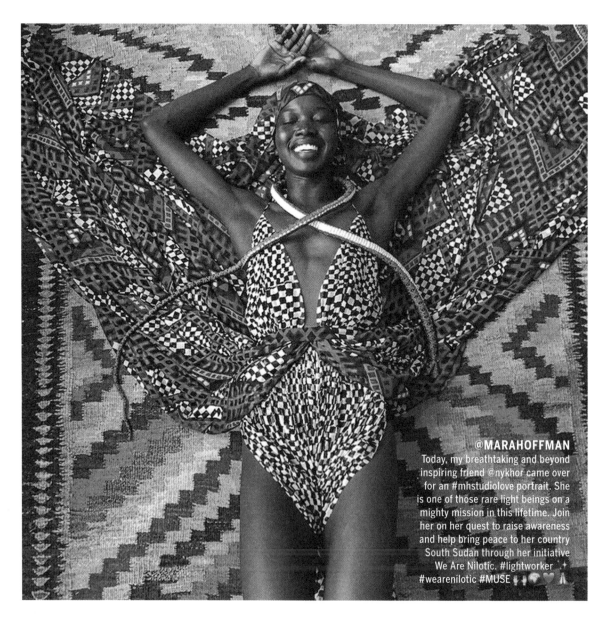

@MARAHOFFMAN
Today, my breathtaking and beyond inspiring friend @nykhor came over for an #mhstudiolove portrait. She is one of those rare light beings on a mighty mission in this lifetime. Join her on her quest to raise awareness and help bring peace to her country South Sudan through her initiative We Are Nilotic. #lightworker #wearenilotic #MUSE

@HENRIBENDEL ↑
A charming display of brights on our web
designer #henribendel #newandnext

@LISAPERRYSTYLE ↗
@hamishbowles nice staging! #vintage
#courreges

@ALICEANDOLIVIA →
So honored to be on the
@vanityfair #bestdressedlist in #halloffame !!
@amyfinecollins

@MARCJACOBSINTL

@RSCOTTFRENCH

@THEELDERSTATESMANOFFICIAL

@JCREW

@NARCISO_RODRIGUEZ

@MONIQUELHUILLIER

@LISAPERRYSTYLE

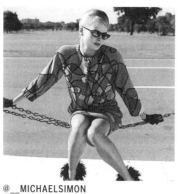

@__MICHAELSIMON

@DAVID_MEISTER

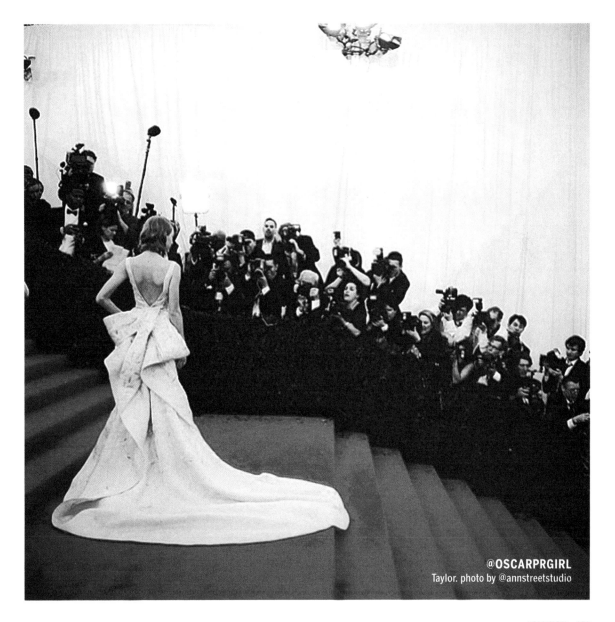

@OSCARPRGIRL
Taylor. photo by @annstreetstudio

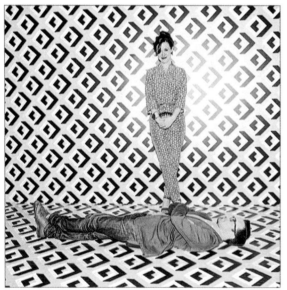

↖ **@MARAHOFFMAN**
Jungle trippin'. #marahoffman
#musthaves #jungletrip
✨🐅🌴🍃🍫💚🍃🐅🌴🐅✨

↑ **@DVF**
Welcome Talita and Sabrina, new generation
of wrappers ! Love Diane #regram

← **@WHIT_NY**
Regram @bfa_nyc from the @dvf exhibit
#journeyofadress #wcfda a little fun
with @parkerargote

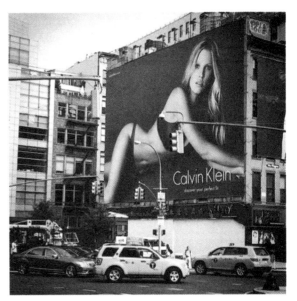

@CALVINKLEIN →
Global Creative Director Kevin Carrigan.
Perfectly lit. A view of the @lara_stone
takeover on Houston and Lafayette
in NYC. #regram

@EDMUNDOCASTILLO ↘
Kassandra Resort 2013

@LISAPERRYSTYLE ↓
Day 2
I don't know why I stood on the stool but
my LP triband dress does match the Nutella
#lisaperry #nutellastyle

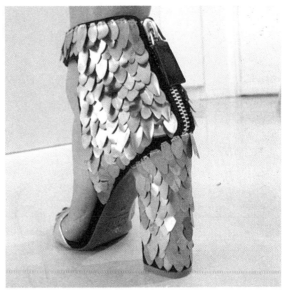

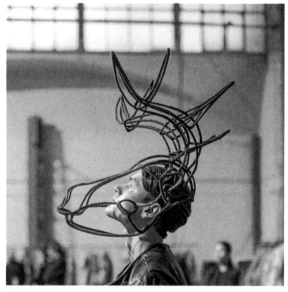

↖ **@RUFFIAN**
Perhaps one of the most serendipitous moments of the day captured backstage by the very talented @schmidtshows

↑ **@THOMBROWNENY**
...stephen jones for thom browne fall 2014... @stephenjonesmillinery

← **@CALVINKLEIN**
Spirited + playful. Global Creative Director of Calvin Klein Jeans and Underwear Kevin Carrigan at the Spring 2015 presentation in Milan. #mfw #mycalvins

@HEISEL_CO →
#Tyvek #Bag #OnLocation photo by
@abstractego @mychaintooheavy

@JOHNVARVATOS ↘
Backstage celebration at the Fall 2014 Milan
Fashion Show featuring rock n' roll icons KISS

@KATESPADENY ↓
swan dive or cannonball? it's endless
summer at the debut of our new swim
collection (launching this november!) and we
can't wait to #divein

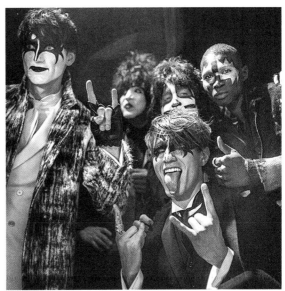

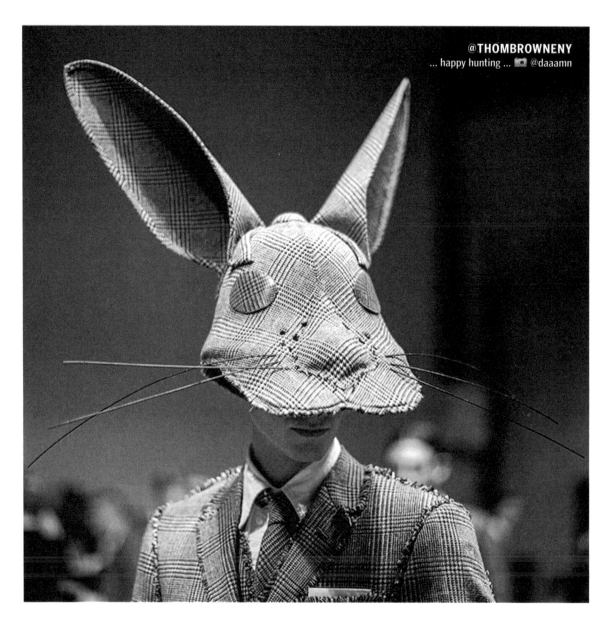

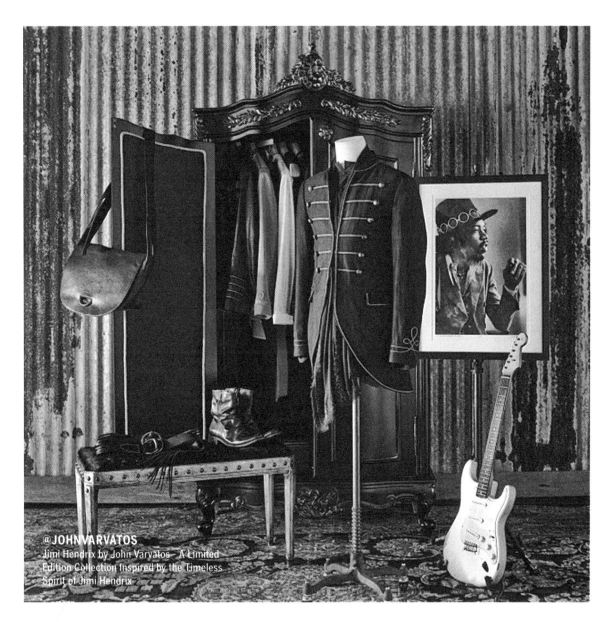

@**JOHNVARVATOS**
Jimi Hendrix by John Varvatos – A Limited
Edition Collection Inspired by the Timeless
Spirit of Jimi Hendrix

@SACHINANDBABI

@OFFICIALANNASUI

@LAEYEWORKS

@MARAHOFFMAN

@VPLNYC

@TOMMYHILFIGER

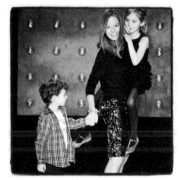

@MILLYBYMICHELLE

@JCOBANDO

@TRINATURK

@REGINAKRAVITZCO

@EUGENIAKIMNYC

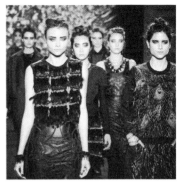

@NICOLEMILLERNYC

@SAM_EDELMAN

@RACHEL_COMEY

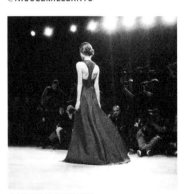

@ANGELSANCHEZPR

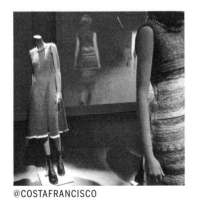

@COSTAFRANCISCO

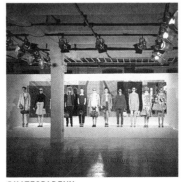

@KATESPADENY

@TIBI

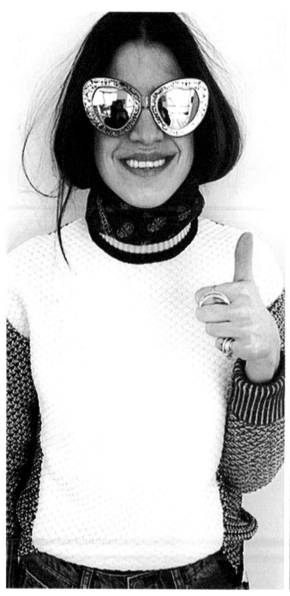
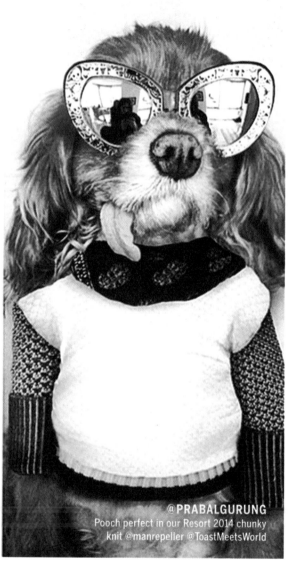

@PRABALGURUNG
Pooch perfect in our Resort 2014 chunky
knit @manrepeller @ToastMeetsWorld

@VERONICABEARD

@EDMUNDOCASTILLO

@PAMELLAROLAND

@PAUL_MARLOW

@NARCISO_RODRIGUEZ

@SACHINANDBABI

@REBECCATAYLORNYC

@TOMMYHILFIGER

@LAURAPORETZKY

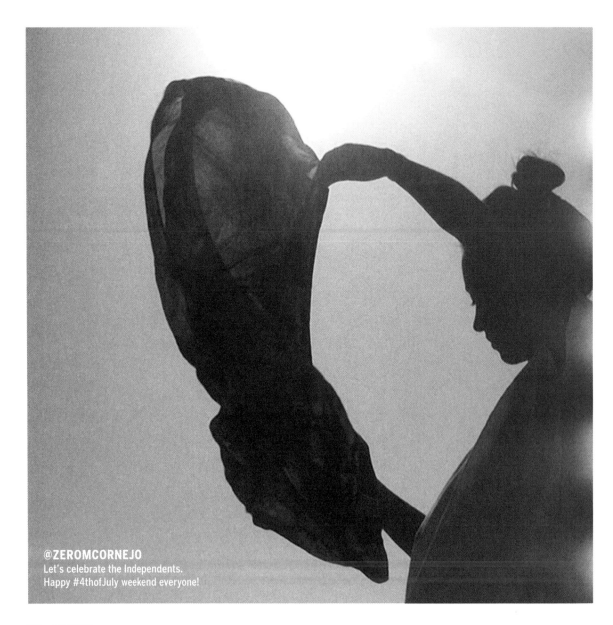

@ZEROMCORNEJO
Let's celebrate the Independents.
Happy #4thofJuly weekend everyone!

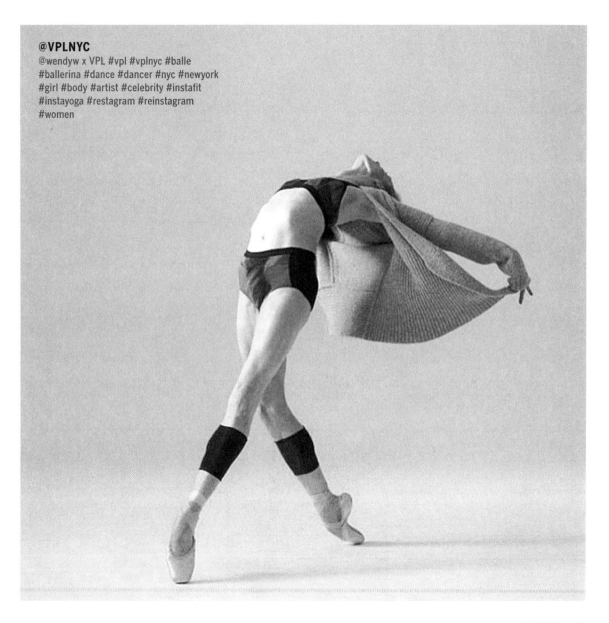

@**VPLNYC**
@wendyw x VPL #vpl #vplnyc #balle
#ballerina #dance #dancer #nyc #newyork
#girl #body #artist #celebrity #instafit
#instayoga #restagram #reinstagram
#women

@SULLYBONNELLY

@KATESPADENY

@MILLYBYMICHELLE

@CANDELANYC

@SELIMAOPTIQUE

@OHNETITELNY

@ANGELSANCHEZPR

@RUFFIAN

@RACHEL_ROY

@ALC_LTD

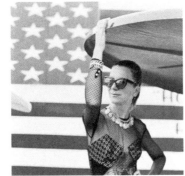

@LULU_FROST

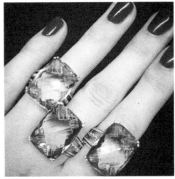

@LAGOS_JEWELRY

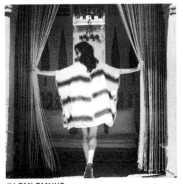

@LEMLEMNYC

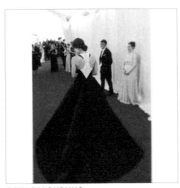

@PRABALGURUNG

@ESQUIVELSHOES

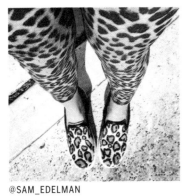

@SAM_EDELMAN

@TITLEOFWORK

@REGINAKRAVITZCO

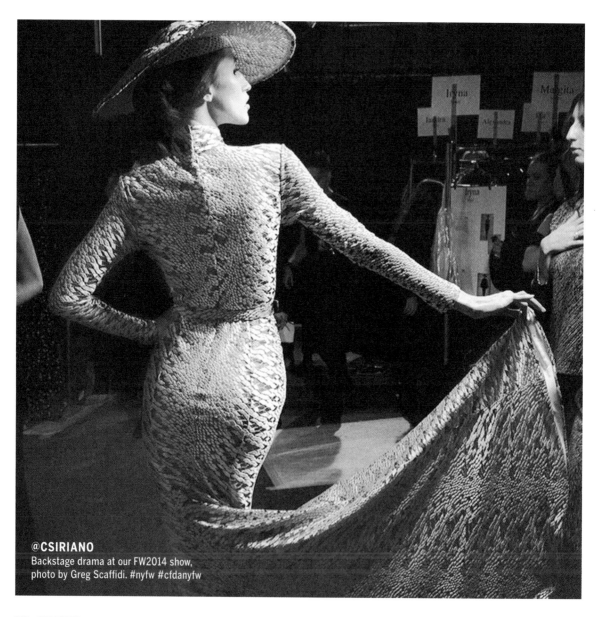

@CSIRIANO
Backstage drama at our FW2014 show,
photo by Greg Scaffidi. #nyfw #cfdanyfw

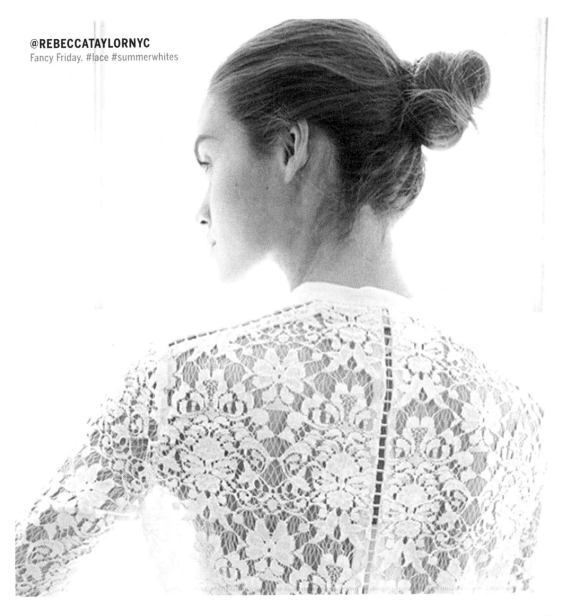

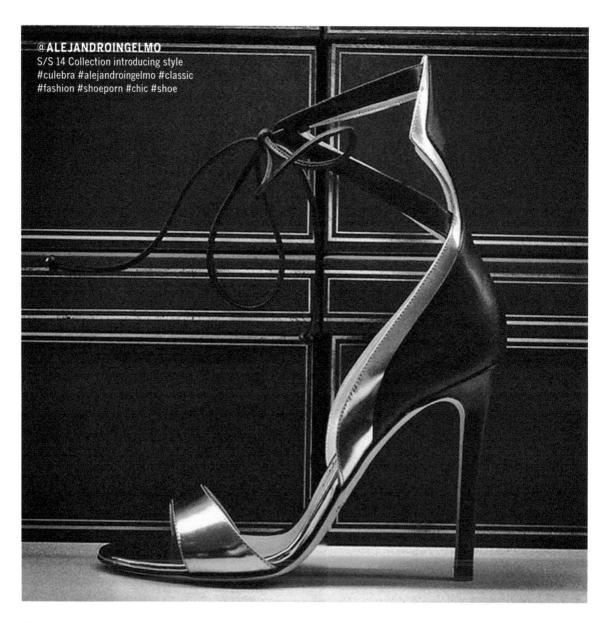

@ALEJANDROINGELMO
S/S 14 Collection introducing style
#culebra #alejandroingelmo #classic
#fashion #shoeporn #chic #shoe

@CATHYWATERMAN

@ILLESTEVA

@MONICARICHKOSANN

@KFALCHI

@JCREW

@MICHAELKORS

@JUDYGEIB

@ERICACOURTNEYJEWELRY

@VITAFEDE

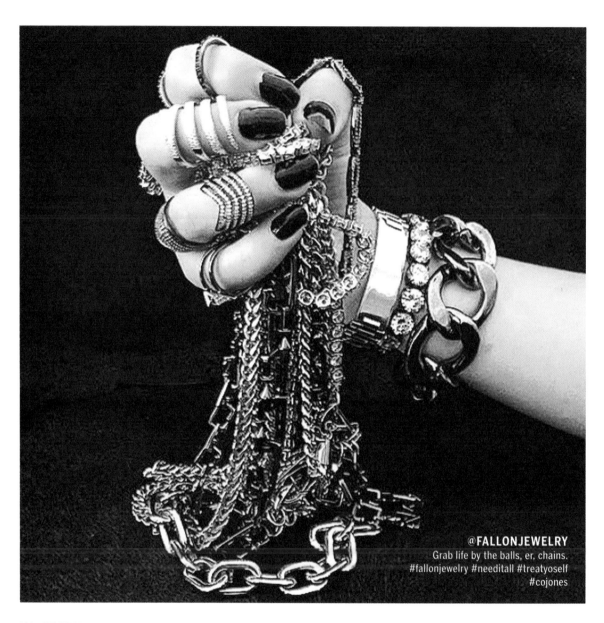

@FALLONJEWELRY
Grab life by the balls, er, chains.
#fallonjewelry #needitall #treatyoself
#cojones

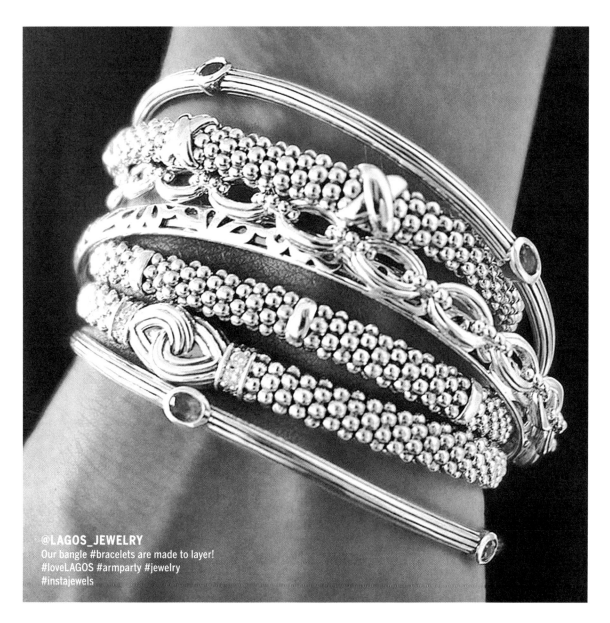

@LAGOS_JEWELRY
Our bangle #bracelets are made to layer!
#loveLAGOS #armparty #jewelry
#instajewels

@ARIDEIN

@CHRISTIANROTHEYEWEAR

@EUGENIAKIMNYC

@JFISHERJEWELRY

@MARCALARY

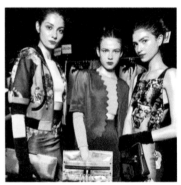

@MILLYBYMICHELLE

@GEMMAREDUX

@LAGOS_JEWELRY

@MONICARICHKOSANN

@REBECCAMINKOFF

@JENMEYERJEWELRY

@MELISSAJOYMANNING

@PAMELALOVENYC

@CATHYWATERMAN

@HOUSEOFHERRERA

@KAYUNGERDESIGN

@MEANDROJEWELRY

@CSIRIANO

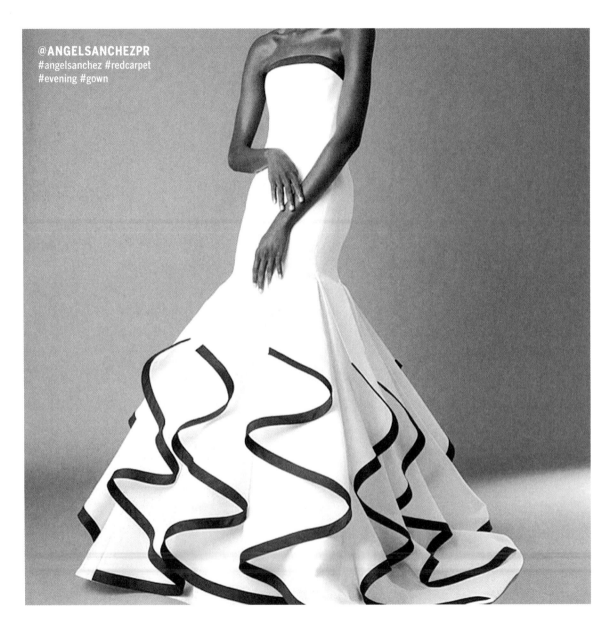

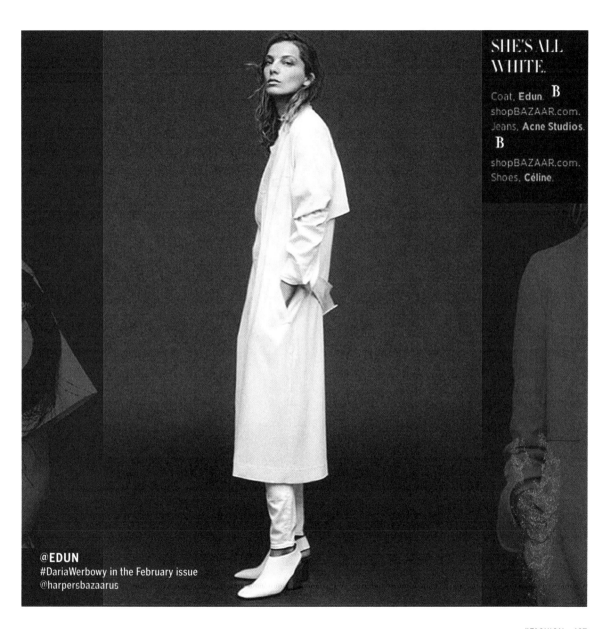

@EDUN
#DariaWerbowy in the February issue
@harpersbazaarus

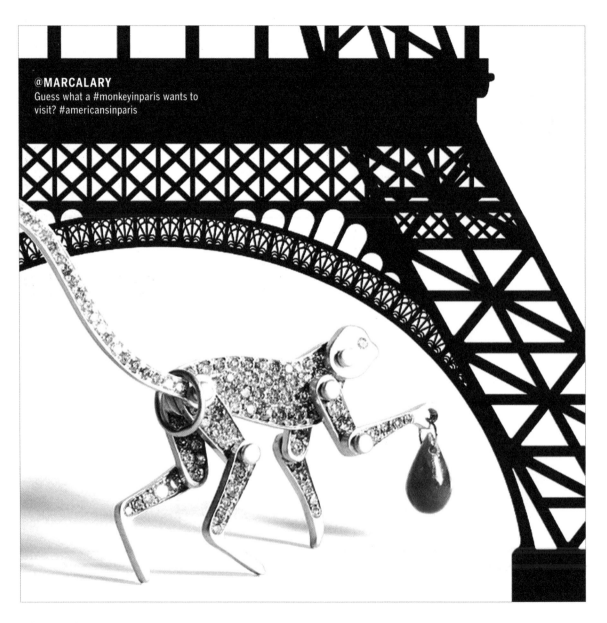

@**MARCALARY**
Guess what a #monkeyinparis wants to visit? #americansinparis

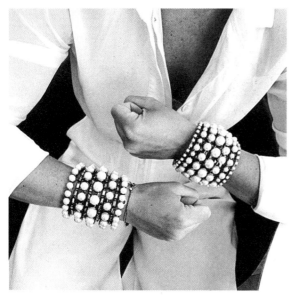

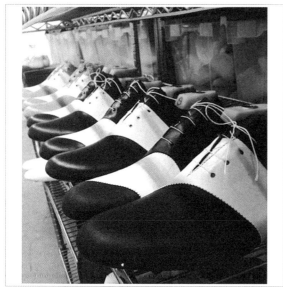

↖ **@ERICKSONBEAMONOFFICIAL**
Look out! @claire_fivestory is armed and dangerous in #ericksonbeamon pearl cuffs 💣 #notyourgrandmaspearls #pearlcuffs #pearls #cuff #statementbracelets #armedanddangerous #statementjewelry #fabulous #allwhiteeverything #workofart #artistry #madebyhand #madeinamerica #craftsmanship #fierce #regram

↑ **@OHNETITELNY**
Backstage, photos by Darren Hall #ohnetitel

← **@ESQUIVELSHOES**
A few of our Lineas in the process of being finished! #esquivel #esquivelshoes

@REBECCAMINKOFF

@SACHINANDBABI

@GIULIETTANEWYORK

@EVAFEHREN

@ALEXISBITTAR

@GILESANDBROTHER

@COLETTEMALOUF

@TRACY_REESE

@KIMBERLYMCDONALDJEWELRY

@VITAFEDE

@KATESPADENY

@LAGOS_JEWELRY

@ASHLEYPITTMANCO

@ALC_LTD

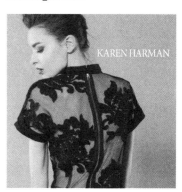

@KARENHARMANINC

@THEROW

@TITLEOFWORK

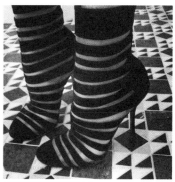

@EDMUNDOCASTILLO

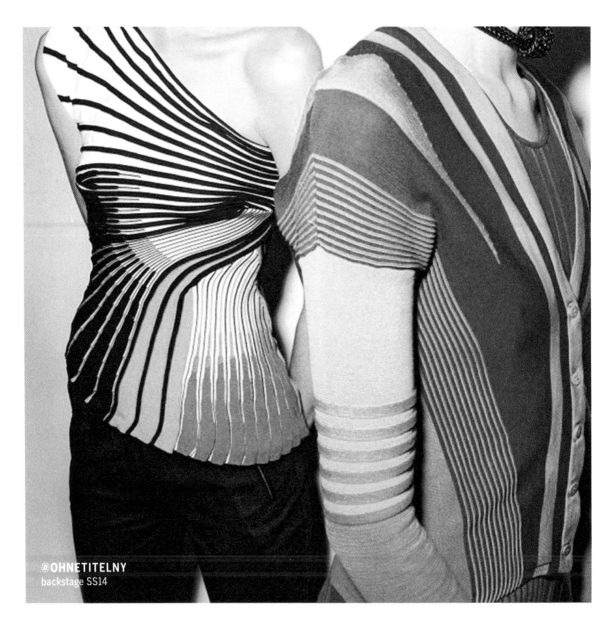

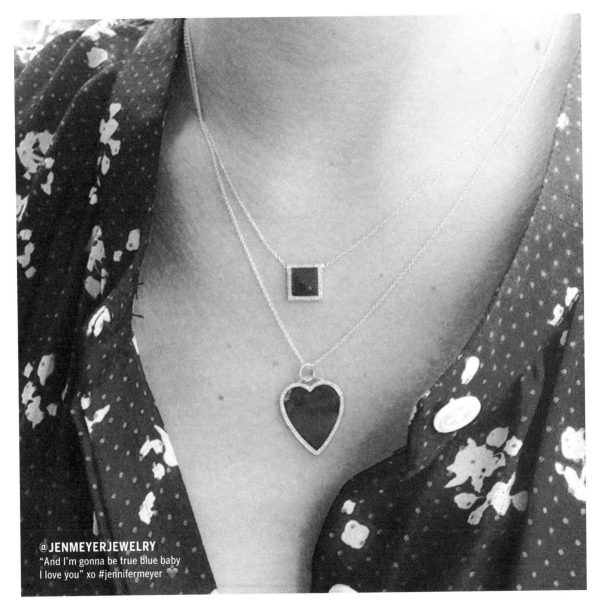

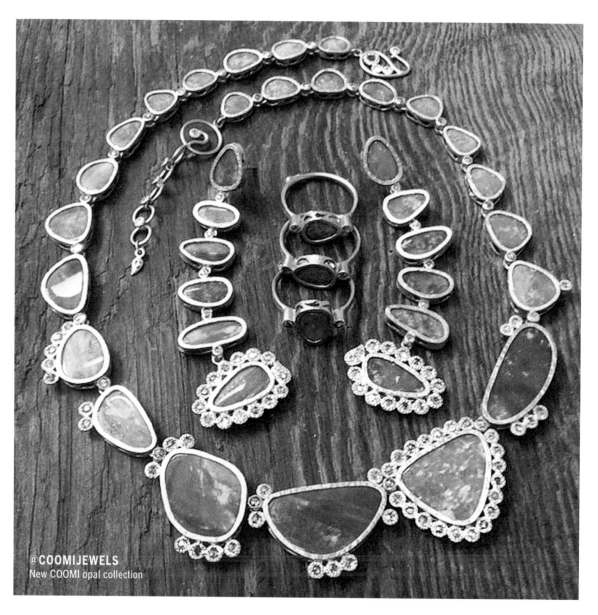

@COOMIJEWELS
New COOMI opal collection

@HENRIBENDEL

@KIMBERLYMCDONALDJEWELRY

@MARCJACOBSINTL

@GERARDYOSCA

@LAEYEWORKS

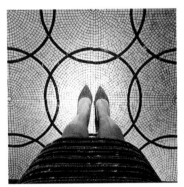

@VINCECAMUTO

@__MICHAELSIMON

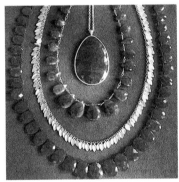

@MEANDROJEWELRY

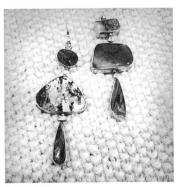

@JUDYGEIB

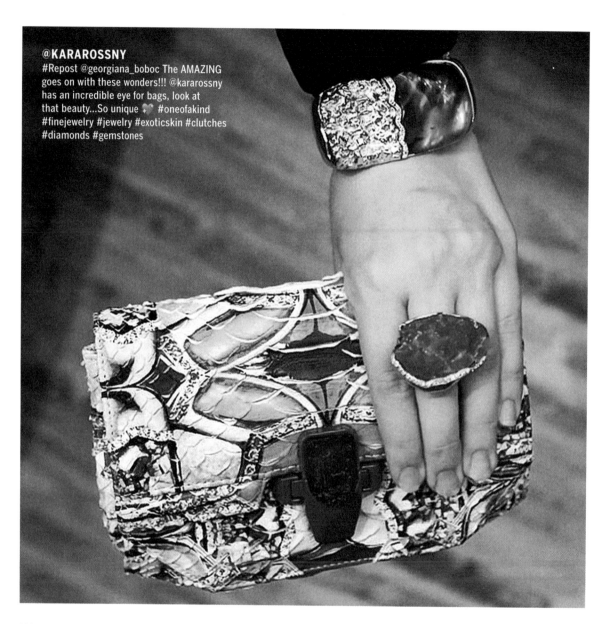

@KARAROSSNY
#Repost @georgiana_boboc The AMAZING
goes on with these wonders!!! @kararossny
has an incredible eye for bags, look at
that beauty...So unique 💎 #oneofakind
#finejewelry #jewelry #exoticskin #clutches
#diamonds #gemstones

↖ **@BOTKIER**
major @songofstyle #regram. she's killing it
with her #coachella style! #festfashion

↑ **@ULLAJOHNSON**
Oh haay my sandals match these beauties
#agathaflat #thinkpink #peonyseason
#ullajohnson 🤍💕🤍🌸

← **@REEM_ACRA**
Another lovely shot from #paris of
#reemacra #resort15 #rtw @shangrilaparis

@JENMEYERJEWELRY

@RSCOTTFRENCH

@ERICKSONBEAMONOFFICIAL

@MIMISOJEWELS

@JUDYGEIB

@JFISHERJEWELRY

@GERARDYOSCA

@SAM_EDELMAN

@RAFENEWYORK

@REBECCAMINKOFF

@TRINATURK

@SELIMAOPTIQUE

@KARAROSSNY

@DANNIJO

@GILESANDBROTHER

@ILLESTEVA

@KFALCHI

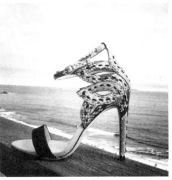

@ALEXANDREBIRMAN

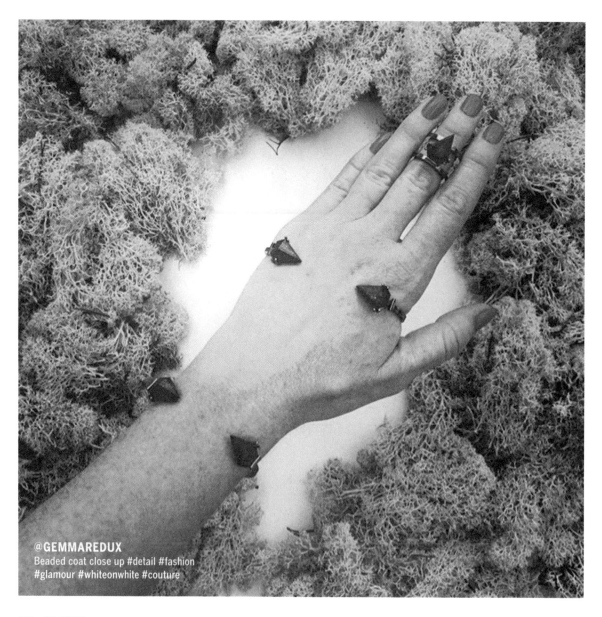

@GEMMAREDUX
Beaded coat close up #detail #fashion
#glamour #whiteonwhite #couture

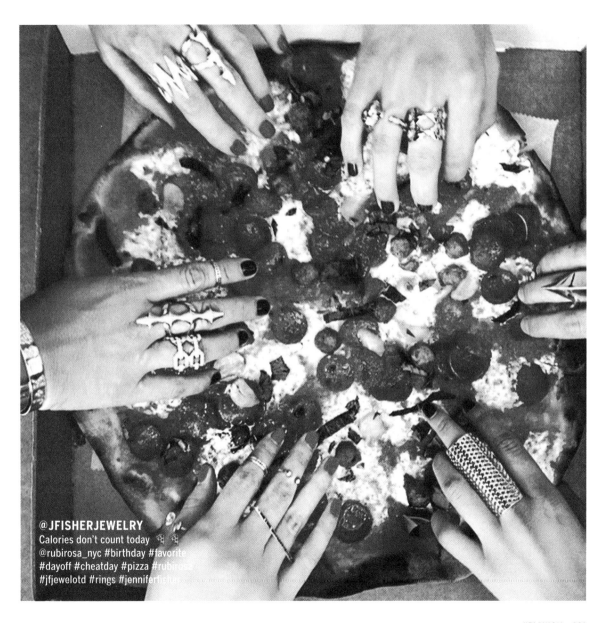

@JFISHERJEWELRY
Calories don't count today 🍕🍕
@rubirosa_nyc #birthday #favorite
#dayoff #cheatday #pizza #rubirosa
#jfjewelotd #rings #jenniferfisher

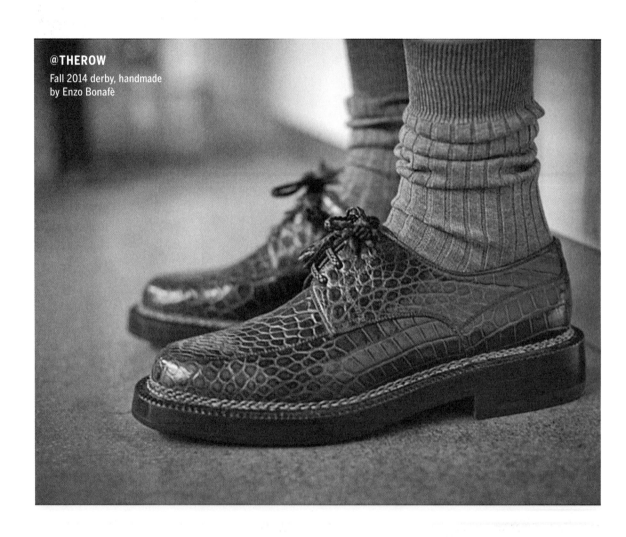

@THEROW

Fall 2014 derby, handmade
by Enzo Bonafè

@VINCECAMUTO

@SAM_EDELMAN

@ALEJANDROINGELMO

@BILLY_REID

@RUTHIE_DAVIS

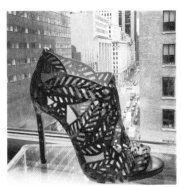

@ALEXANDREBIRMAN

@VANESSANOELSTYLE

@TIBI

@TABITHASIMMONS

@FIONAKOTUR

@DANNIJO

@GGUBLO67

@ZEROMCORNEJO

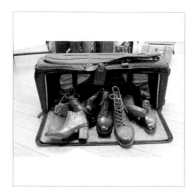

@ESQUIVELSHOES

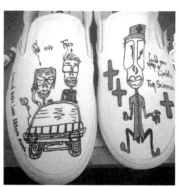

@CHROMEHEARTSOFFICIAL

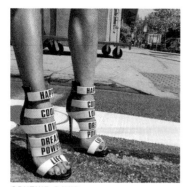

@RUTHIE_DAVIS

@TOMMYHILFIGER

@EDMUNDOCASTILLO

@ULRICHCPS

@ASSEMBLYNEWYORK

@GIULIETTANEWYORK

@TOMS

@MARCJACOBSINTL

@TABITHASIMMONS

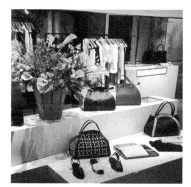

@MAIYET

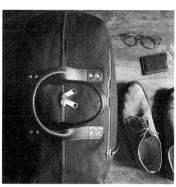

@ERNESTALEXANDER

@SAM_EDELMAN

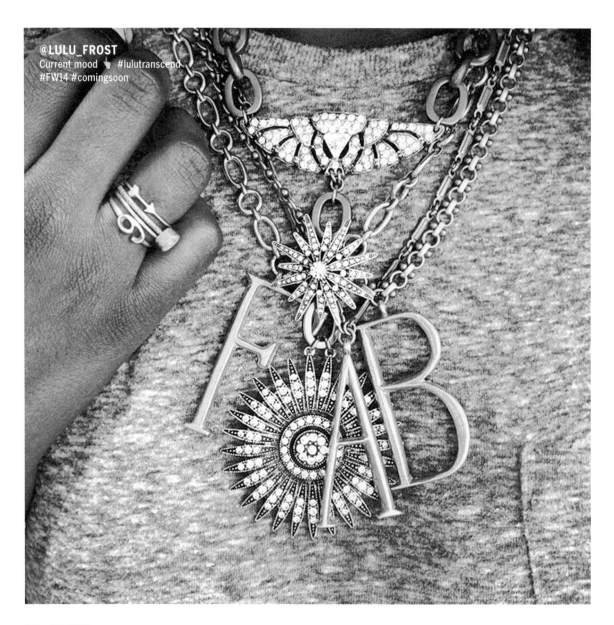

@LULU_FROST
Current mood 👇 #lulutranscend
#FW14 #comingsoon

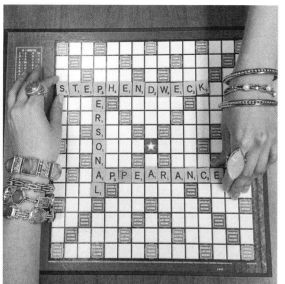

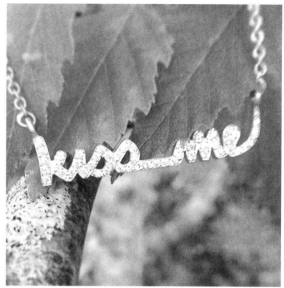

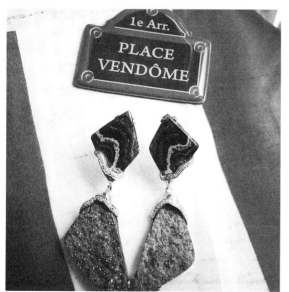

↖ **@STEPHENDWECK**
Stephen will be visiting @NeimanMarcus
in Troy, #Michigan tomorrow from
11-4 p.m. If you are in the area stop by
& say hi! #NeimanMarcus #trunkshow
#beautifuljewelry

↑ **@MEANDROJEWELRY**
The necklace says it all! #meandro #kissme
#sweetsentiments #gold #pavediamonds
#valentinesday #giftideas

← **@KARAROSSNY**
Showing r #finejewelry collection
here n #paris at the @hoteldevendome
#pfw #luxury #parisfashionweek #jewelry
#diamonds

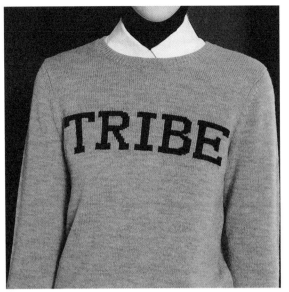

@ALC_LTD ↑
As in the tribe. As in #TribeALC -#fall14
A.L.C. Knits

@BURKMANBROS ↗
On set for @BurkmanBros' #ss15 look book.
Ride on! 🏄🏄 #love #photo
#instaphoto #makeawesomeclothes
#lookbook #burkmanbros #menswear
#light #instagood #ny #mensfashion #sun
#fun #nyc #potd #instamood

@CLAREVIVIER →
Finally! Our Frenchie t-shirts for sale at our
shop tomorrow night for poster event in LA.

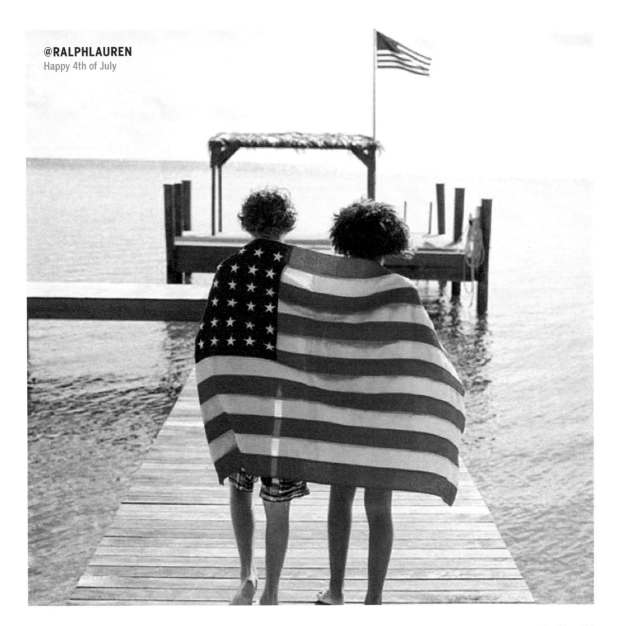

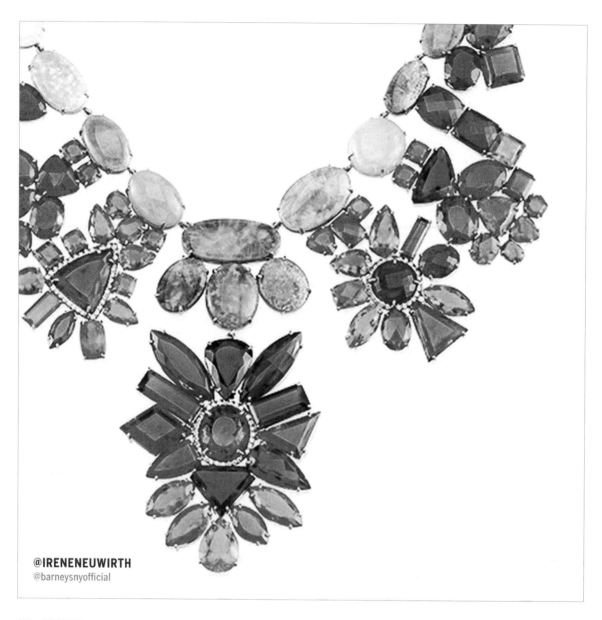

@IRENENEUWIRTH
@barneysnyofficial

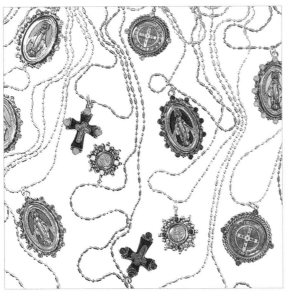

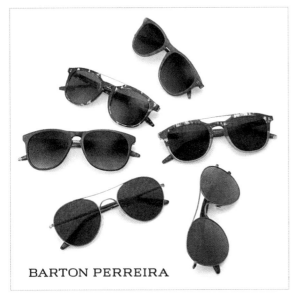

BARTON PERREIRA

↖ **@VSA_DESIGNS**
#charming #wearitandbelieve #vsacrosses
#vsadesigns #vsamilagrosa #vsacharms
#vsasanbenito

↑ **@REBECCAMINKOFF**
Governors Ball kicks off today and we
couldn't be more excited! Head over to
#RMEDIT and check out our #RMGOVBALL
Survival Kit- so you can have fun in the sun
without worrying about a thing!

← **@BARTONPERREIRA**
SAKS FIFTH AVENUE | Mens Accessories
Chicago Invites You To View The New
BARTON PERREIRA Sunglass Collection
Thursday-Friday June 12th - June 13th
#saksfifthave #bartonperreira

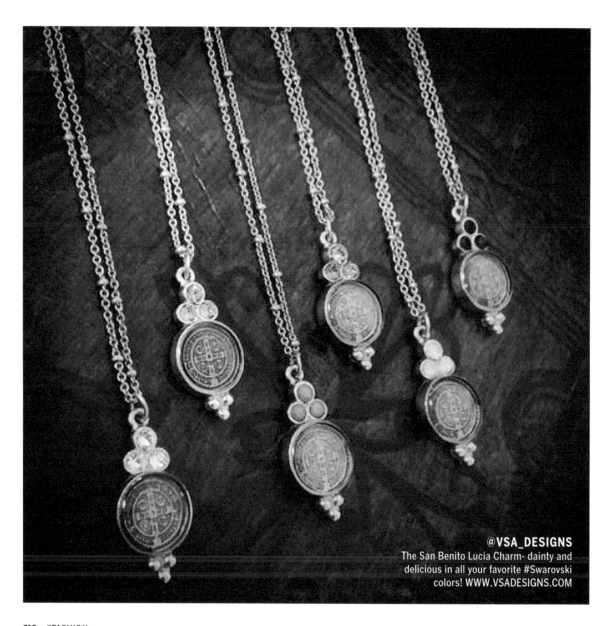

@VSA_DESIGNS
The San Benito Lucia Charm- dainty and
delicious in all your favorite #Swarovski
colors! WWW.VSADESIGNS.COM

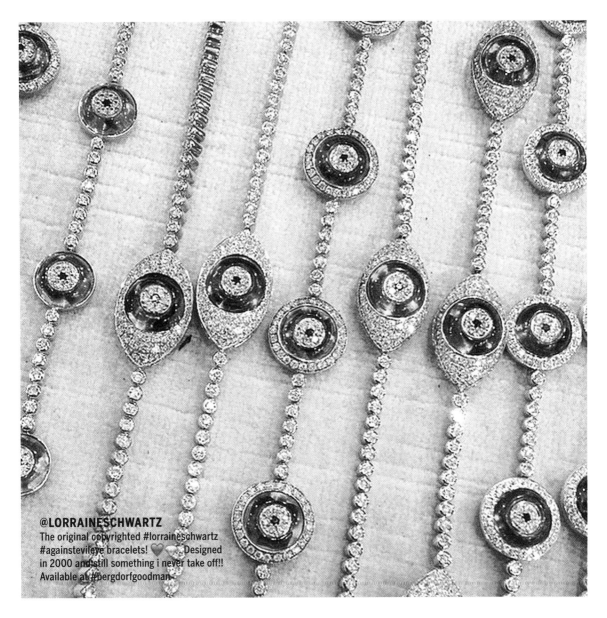

@LORRAINESCHWARTZ
The original copyrighted #lorraineschwartz
#againstevileye bracelets! 🤍 Designed
in 2000 and still something i never take off!!
Available at #bergdorfgoodman

@EDMUNDOCASTILLO

@BILLY_REID

@HOUSEOFLAFAYETTE

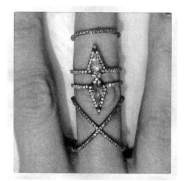

@EVAFEHREN

@OFFICIALDUCKIEBROWN

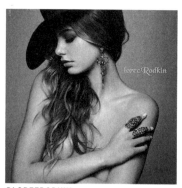

@LOREERODKIN

@ERICJAVITS

@REEDKRAKOFF

@ASHLEYPITTMANCO

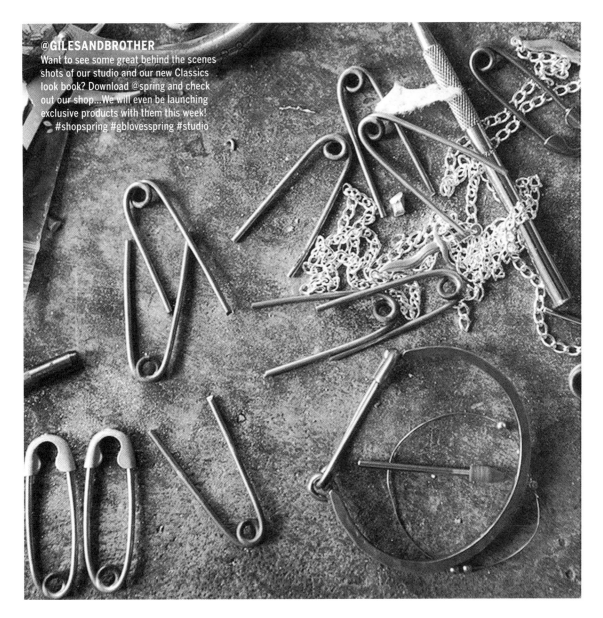

@GILESANDBROTHER
Want to see some great behind the scenes shots of our studio and our new Classics look book? Download @spring and check out our shop...We will even be launching exclusive products with them this week! #shopspring #gblovesspring #studio

@FALLONJEWELRY

@LAEYEWORKS

@MARYMCFADDENINC

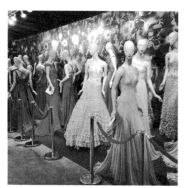

@BCBGMAXAZRIA

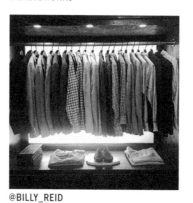

@BILLY_REID

@ERICACOURTNEYJEWELRY

@COOMIJEWELS

@ZEROMCORNEJO

@CLAREVIVIER

@BARTONPERREIRA

@KFALCHI

@PRABALGURUNG

@KIMBERLYMCDONALDJEWELRY

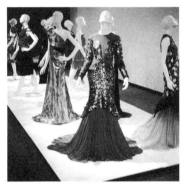

@BIBHUMOHAPATRA

@PAMELALOVENYC

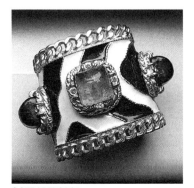

@GERARDYOSCA

@FIONAKOTUR

@BOTKIER

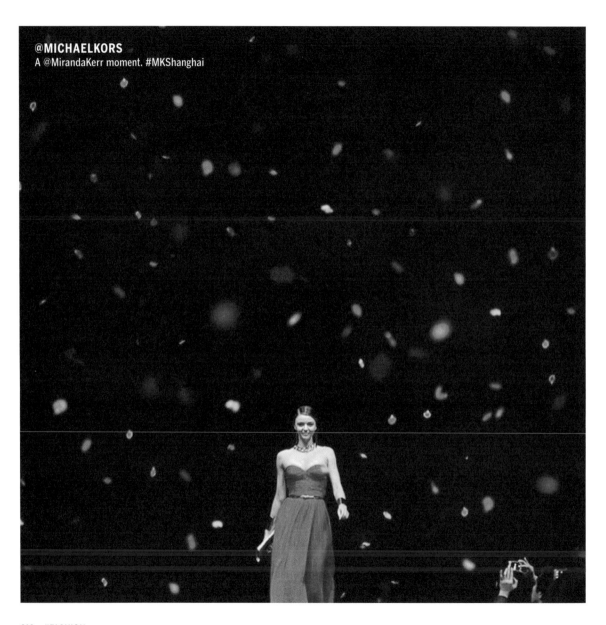

@**MICHAELKORS**
A @MirandaKerr moment. #MKShanghai

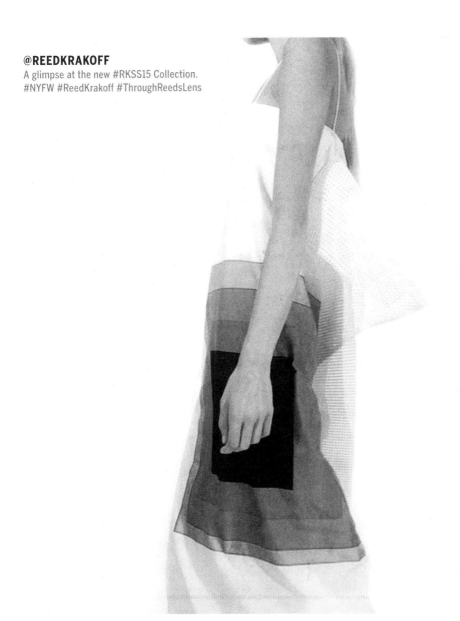

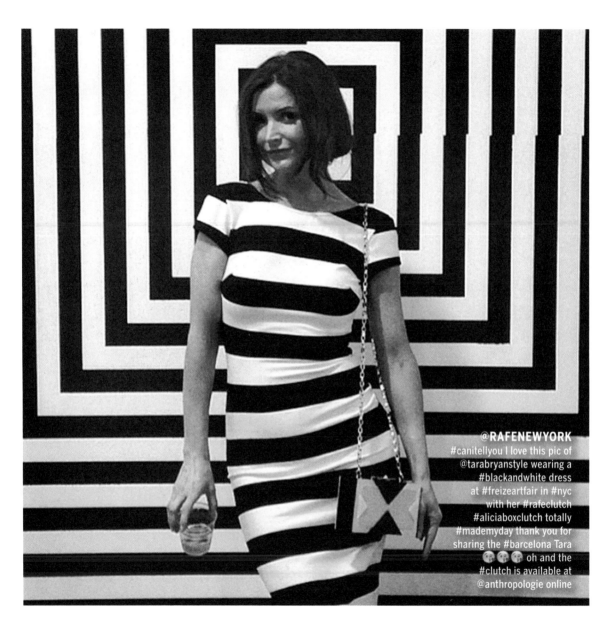

@RAFENEWYORK
#canitellyou I love this pic of @tarabryanstyle wearing a #blackandwhite dress at #freizeartfair in #nyc with her #rafeclutch #aliciaboxclutch totally #mademyday thank you for sharing the #barcelona Tara 😂😂😂 oh and the #clutch is available at @anthropologie online

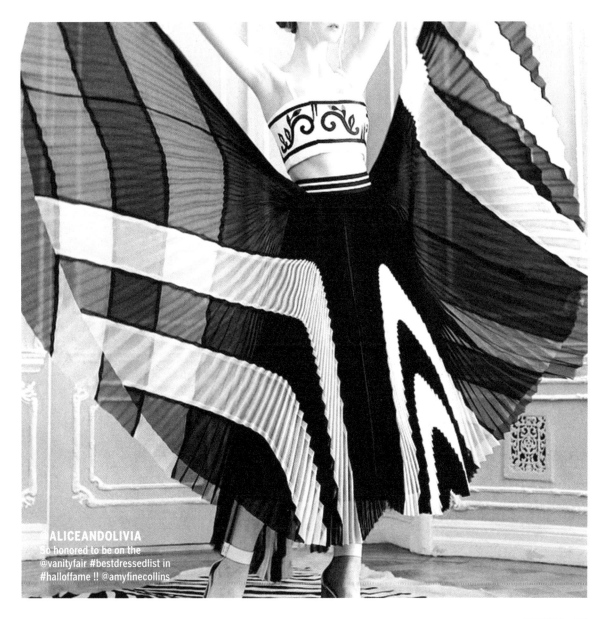

@ALICEANDOLIVIA
So honored to be on the
@vanityfair #bestdressedlist in
#halloffame !! @amyfinecollins

@MONIQUEPEAN

@MARYMCFADDENINC

@REBECCATAYLORNYC

@NATORICOMPANY

@VINCECAMUTO

@TALBOTRUNHOF

@OFFICIALRODARTE

@JFISHERJEWELRY

@DANNIJO

@ERNESTALEXANDER

@JOHNBARTLETT8

@JUSSARALEE

@KARAROSSNY

@COOMIJEWELS

@KIMBERLYMCDONALDJEWELRY

@MICHAELKORS

@MAIYET

@LORRAINESCHWARTZ

@THEROW

@THEELDERSTATESMANOFFICIAL

@VITAFEDE

@TITLEOFWORK

@GIULIETTANEWYORK

@STEPHENDWECK

@TODDSNYDERNY

@GEMMAKAHNG

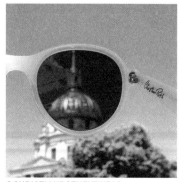

@CHRISTIANROTHEYEWEAR

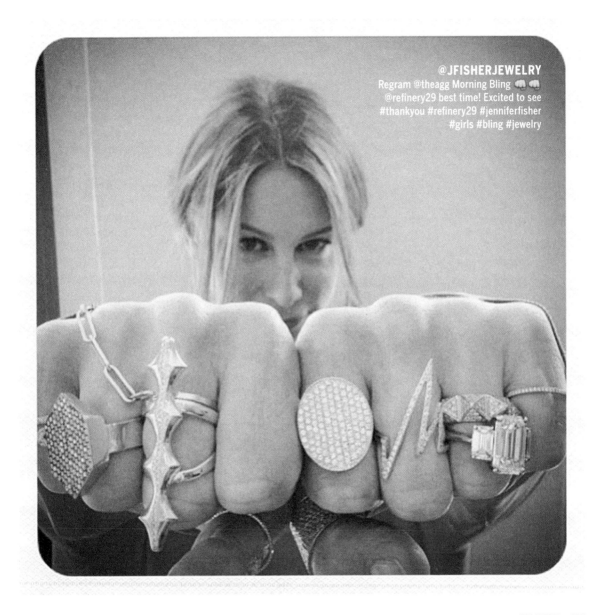

@JFISHERJEWELRY
Regram @theagg Morning Bling 👊👊
@refinery29 best time! Excited to see
#thankyou #refinery29 #jenniferfisher
#girls #bling #jewelry

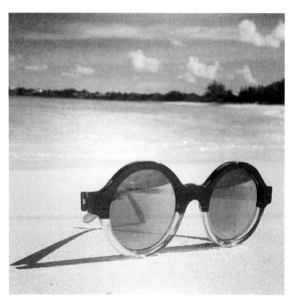

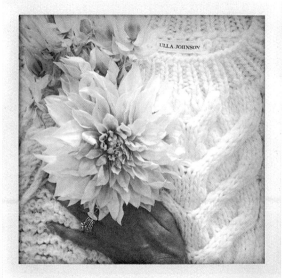

@ILLESTEVA ↑
Dreaming of better weather

@ULLAJOHNSON ↗
Coming soon 🌸 #getspring #fall14
#ullajohnson @spring

@TALBOTRUNHOF →
we wish you all a fabulous easter!
#talbotrunhof #boutique #paris
#munich #team

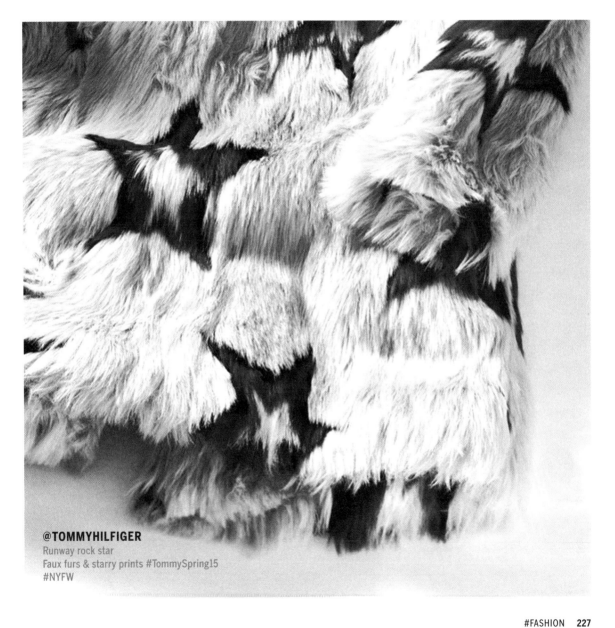

@TOMMYHILFIGER
Runway rock star
Faux furs & starry prints #TommySpring15
#NYFW

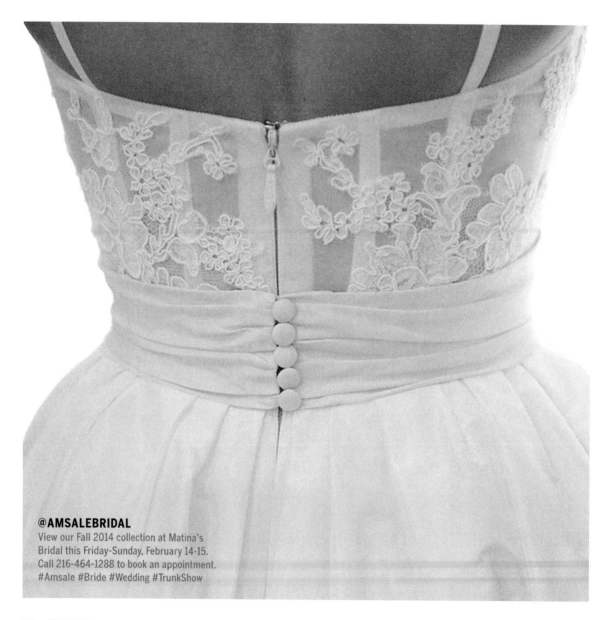

@LORRAINESCHWARTZ
This is what my crew at the office do when
I'm out! #cupcakesandpinkdiamonds
#phewthediamondsareok #dessertanyone
#justanotherdayintheoffice
#theyatethemall #LSgirls #happyfriday
#lorraineschwartzjewelry 🤍💎

↖ **@JENMEYERJEWELRY**
A little bit of love and luck today
🤍 xo #jennifermeyer

↑ **@DANNIJO**
it's 10:44, do you know where your pug is?
#putabibonit

← **@LOREERODKIN**
Dinner w #eltonjohn in Loreerodkin jewelry
@davidfurnish le petit Maison st tropez

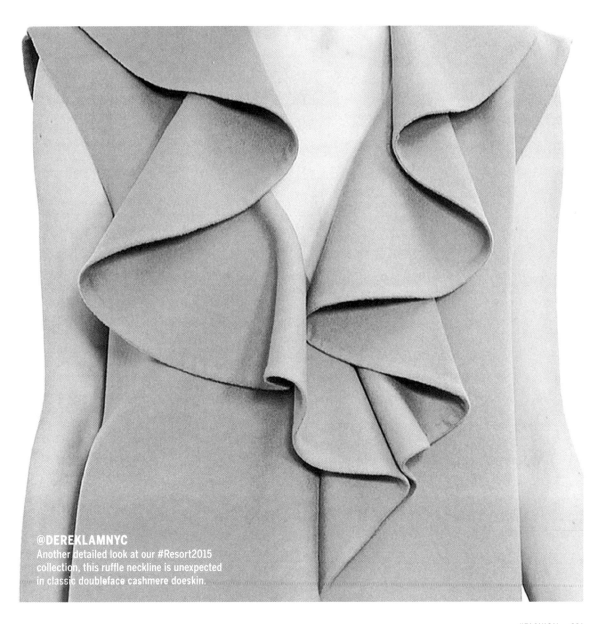

← @HOUSEOFHERRERA
#insidetheatelier #carolinaherrera crafting the #weddingdress. New collection APRIL 11.

↙ @NANETTELEPORE
Intricate details having a moment in my ny showroom

↓ @MONIQUELHUILLIER
Too hard to choose just one! 💍💍💍 @bluenilediamond #regram @brides #diamonds #engagementring

@ULLAJOHNSON →
Amazing Serbian puckered cotton and lace blouse #momscloset #handmade #heirloom #thankyou

@LAGOS_JEWELRY ↘
#NYC can be quite #romantic, yes? @eatsleepwear layers our gold Covet rings in a way that sets our hearts aflutter! Counting down to #ValentinesDay, we'll be dedicating a post to one of our fans every day! For a chance to be featured, share your LAGOS with us by using the hashtag #loveLAGOS

@HENRIBENDEL ↓
Sneak peek of our fave petal pink for Spring 2014! Flowers c/o @saipua

@ME_CUTANDSEW

@CATHYWATERMAN

@ULLAJOHNSON

@VINCECAMUTO

@CARLOSMIELEOFICIAL

@MARYMCFADDENINC

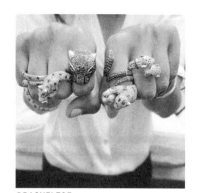

@RACHELZOE

@SELIMAOPTIQUE

@PAIGENOVICK

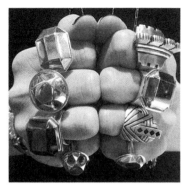

@LISAJENKSJEWEL

@RUTHIE_DAVIS

@CHRISTIANROTHEYEWEAR

@ILLESTEVA

@PAMELLAROLAND

@GEMMAKAHNG

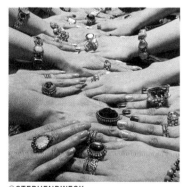

@STEPHENDWECK

@NATORICOMPANY

@ERNESTALEXANDER

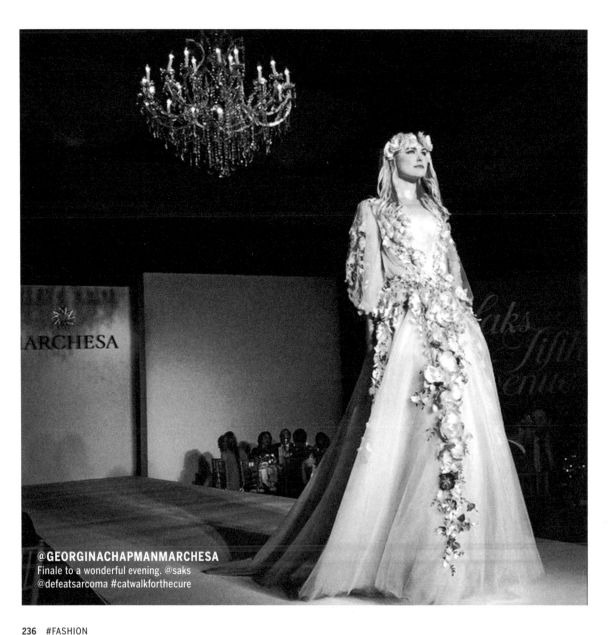

@GEORGINACHAPMANMARCHESA
Finale to a wonderful evening. @saks
@defeatsarcoma #catwalkforthecure

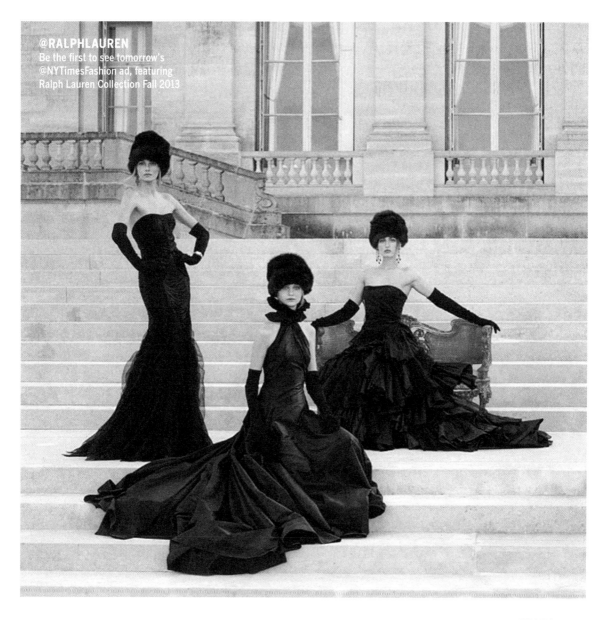

@CFDA
Success! Thanks to everyone who came out
to yesterday's #CFDAincubatorshowcase.

@ME_CUTANDSEW

@CHILIDROD

@JEFFHALMOS_

@MEANDROJEWELRY

#TBT

@ASHLEYPITTMANCO

@ALEXISBITTAR

@ANGELSANCHEZPR

@ALBERTUS_SWANEPOEL
#tbt. Young and sporty! #ostrich jockey
#southafrica

@CANDELANYC
My dad 1981. Happy Friday! Besos Gabi

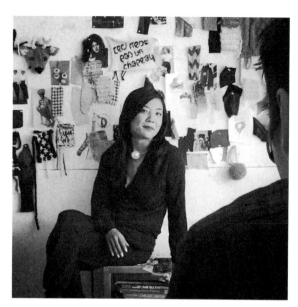

← **@EUGENIAKIMNYC**
Outtake from my shoot and interview for the June issue of @harpersbazaargermany. Read all about my FW14 inspiration. On stands now! - EK #tbt #harpersbazaargermany

↙ **@PAMELLAROLAND**
One of my favorite moments in Greece three year ago. So much beauty around us! Can't wait to be back there someday...XO, P. #throwbackthursday #tbt #greece

↓ **@ANDREW_FEZZA**
#tbt to the spring 2014 Photoshoot with VNY model @mac_hedbrandh and hairstylist Jordan M. (Makeup credit to Anne Kohlhagen) #andrewfezza #menswear #style #photoshoot #behindthescenes #spring

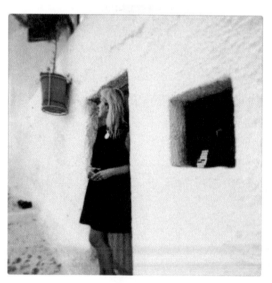

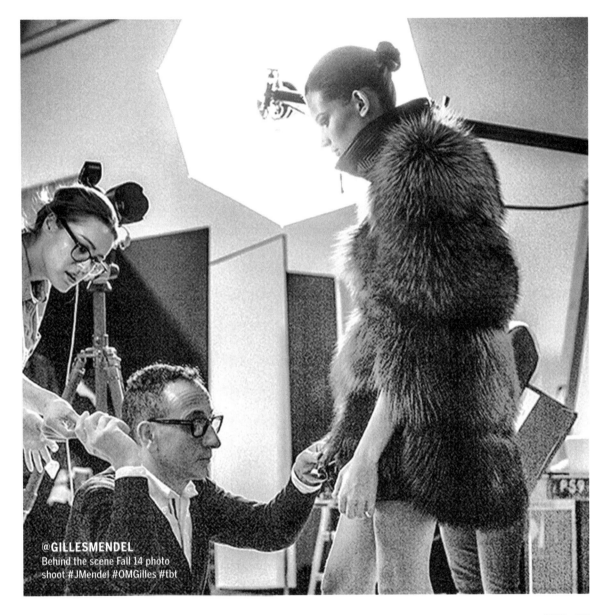

@GILLESMENDEL
Behind the scene Fall 14 photo
shoot #JMendel #OMGilles #tbt

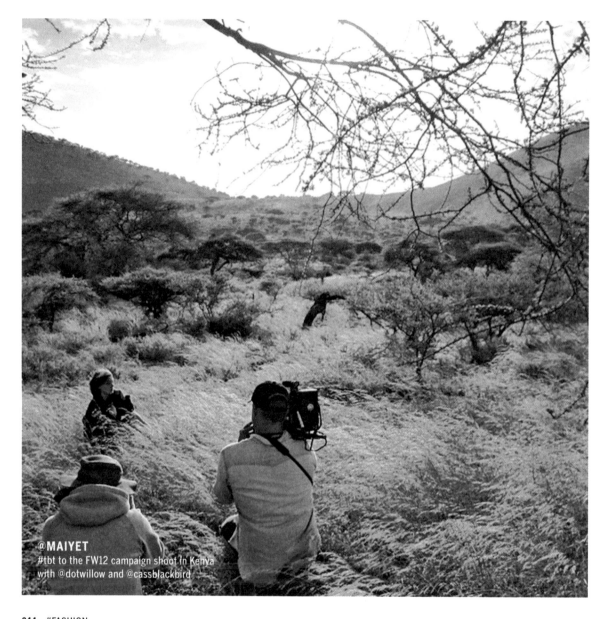

@MAIYET
#tbt to the FW12 campaign shoot in Kenya
with @dotwillow and @cassblackbird

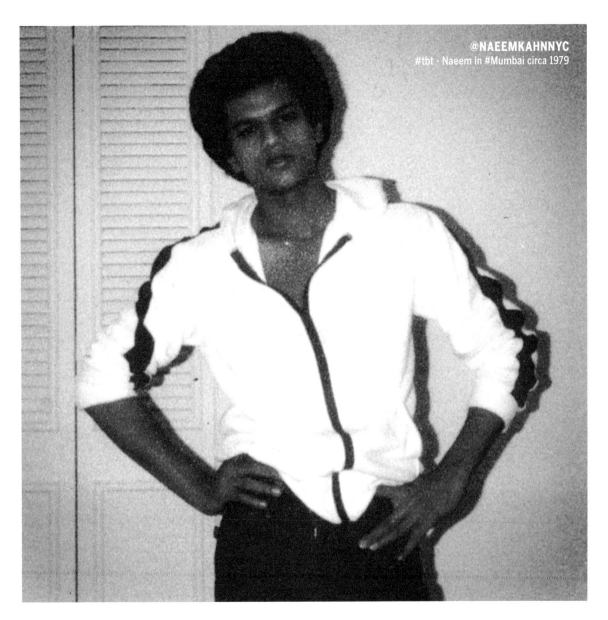

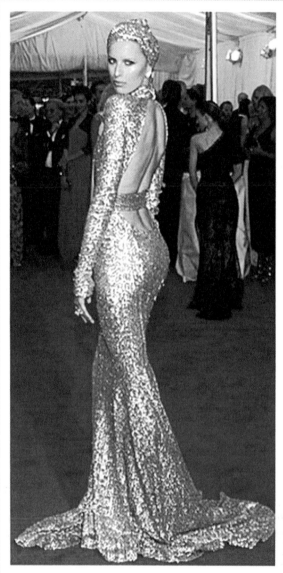

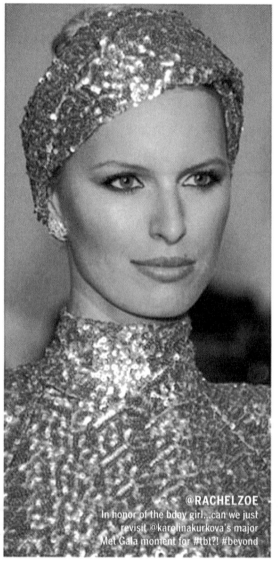

@RACHELZOE
In honor of the bday girl...can we just
revisit @karolinakurkova's major
Met Gala moment for #tbt?! #beyond

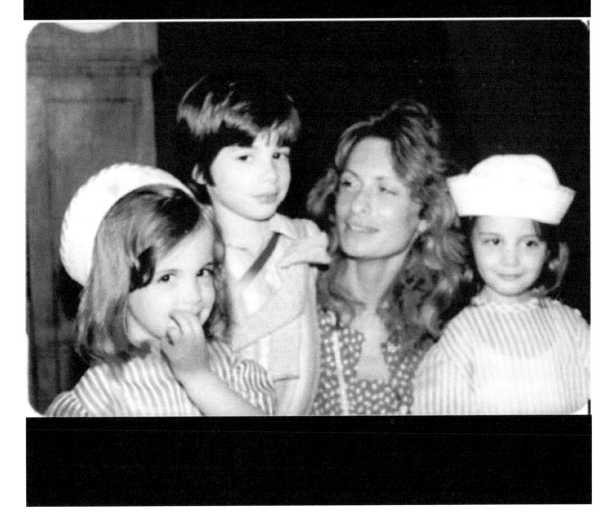

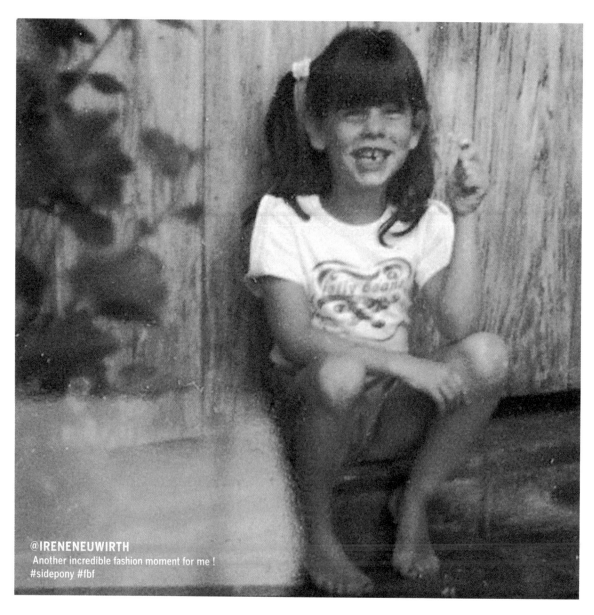

@IRENENEUWIRTH
Another incredible fashion moment for me !
#sidepony #fbf

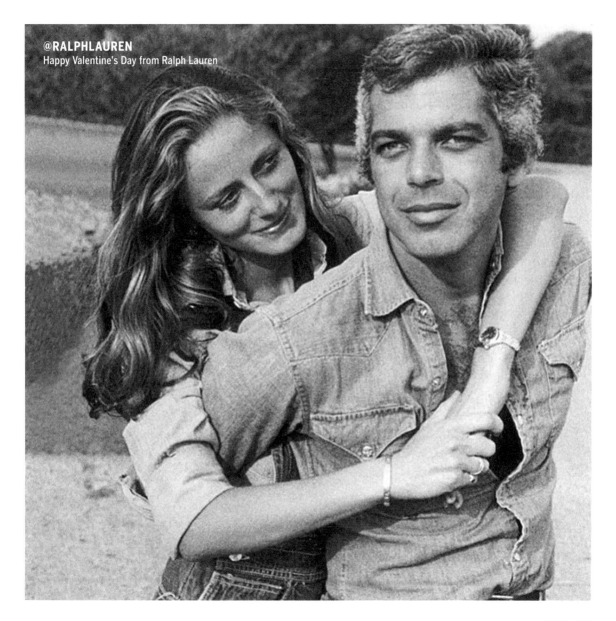

CONTRIBUTOR LIST

@__michaelsimon
Michael Simon

@alabamachanin
Natalie Chanin
Alabama Chanin

@albertus_swanepoel
Albertus Swanepoel

@alc_ltd
Andrea Lieberman
A.L.C.

@alejandroingelmo
Alejandro Ingelmo

@alexandrebirman
Alexandre Birman

@alexisbittar
Alexis Bittar

@aliceandolivia
Stacey Bendet
*Alice + Olivia by
 Stacey Bendet*

@amourvert
Linda Balti
Amour Vert

@amsalebridal
Amsale Aberra

@andrew_fezza
Andrew Fezza

@angelsanchezpr
Angel Sanchez

@apolis
Raan and Shea Parton
Apolis

@araks_yeramyan
 Araks Yeramyan

@aridein
Arielle Shapiro
Ari Dein

@ashleypittmanco
Ashley Pittman

@assemblynewyork
Greg Armas
Assembly New York

@bartonperreira
Patty Perreira
Barton Perreira

@bcbgmaxazria
Max Azria and Lubov Azria
BCBGMAXAZRIAGROUP

@bibhumohapatra
Bibhu Mohapatra

@billy_reid
Billy Reid

@botkier
Monica Botkier
Botkier

@burkmanbros
Doug and Ben Burkman
Burkman Bros.

@calvinklein
Kevin Carrigan
Calvin Klein

@candelanyc
Gabriela Perezutti Hearst
Candela

@carloscamposdesigner
Carlos Campos

@carlosmieleoficial
Carlos Miele

@cathywaterman
Cathy Waterman

@charlotteronson
Charlotte Ronson

@chereskinstudio
Ron Chereskin

@chilidrod
David Rodriguez
*David and David
 New York Inc.*

@chochman1
Carole Hochman

@christianrotheyewear
Christian Roth
Christian Roth Eyewear

@chromeheartsofficial
Richard Stark and
 Laurie Lynn Stark
Chrome Hearts

@clarevivier
Clare Vivier

@colettemalouf
Colette Malouf

@coomijewels
Coomie Bhasin
COOMI

@costafrancisco
Francisco Costa
Calvin Klein

@costellotagliapietra
Jeffrey Costello and
 Robert Tagliapietra
Costello Tagliapietra

@csiriano
Christian Siriano

@cynthia_rowley
Cynthia Rowley

@cynthiasteffe
Cynthia Steffe

@cynthiavincent
Cynthia Vincent
*Twelfth Street by
 Cynthia Vincent*

@dannijo
Danielle and Jodie Snyder
Dannijo

@david_meister
David Meister

@dennisbasso
Dennis Basso

@dereklamnyc
Derek Lam

@dieselblackgold
Andreas Melbostad
Diesel Black Gold

@donnakaranthewoman
Donna Karan

@dvf
Diane von Furstenberg

@edmundocastillo
Edmundo Castillo

@edun
Danielle Sherman
Edun

@ericacourtneyjewelry
Erica Courtney

@ericjavits
Eric Javits

@ericksonbeamonofficial
Karen & Eric Erickson and
 Vicki Beamon
Erickson Beamon

@erinfetherston
Erin Fetherston

@ernestalexander
Ernest Sabine
Ernest Alexander

@esquivelshoes
George Esquivel
Esquivel Shoes

@eugeniakimnyc
Eugenia Kim

@evafehren
Eva Zuckerman
Eva Fehren

@fallonjewelry
Dana Lorenz
FALLON Jewelry

@fionakotur
Fiona Kotur Marin
Kotur

@gemmakahng
Gemma Kahng

@gemmaredux
Rachel Dooley
Gemma Redux

@georginachapmanmarchesa
Georgina Chapman
Marchesa

@gerardyosca
Gerard Yosca

@gilesandbrother
Philip Crangi
Giles & Brother

@gillesmendel
Gilles Mendel
J. Mendel

@giuliettanewyork
Sofia Sizzi
Giulietta New York

@Ggublo67
George Gublo
Highline NY

@hatunderwood
Patricia Underwood

@heisel_co
Sylvia Heisel
Heisel

@henribendel
Pina Ferlisi
Henri Bendel

@houseofherrera
Carolina Herrera

@houseoflafayette
Virginie Promeyrat
House of Lafayette

@illesteva
Daniel Silberman and
 Justin Salguero
Illesteva

@ireneneuwirth
Irene Neuwirth

@italozucchelli
Italo Zucchelli
Calvin Klein

@JackieRogers000
Jackie Rogers

@jasonwu
Jason Wu

@jcobando
Juan Carlos Obando

@jcrew
Jenna Lyons
J.Crew

@jeffhalmos_
Jeff Halmos
Shipley & Halmos

@jenmeyerjewelry
Jennifer Meyer
Jennifer Meyer Jewelry

@jfisherjewelry
Jennifer Fisher

@johnbartlett8
John Bartlett

@johnvarvatos
John Varvatos

@judygeib
Judy Geib
Judy Geib Plus Alpha

@jussaralee
Jussara Lee

@kararossny
Kara Ross
Kara Ross NY

@karenharmaninc
Karen Harman

@katespadeny
Deborah Lloyd
kate spade new york

@kayungerdesign
Kay Unger

@keananduffty
Keanan Duffty

@kerencraigmarchesa
Keren Craig
Marchesa

@kfalchi
Carlos Falchi

@kimberlymcdonaldjewelry
Kimberly McDonald

@laeyeworks
Gai Gherardi and
 Barbara McReynolds
L.A. Eyeworks

@lagos_jewelry
Steven Lagos
Lagos

@lauraporetzky
Laura Poretzky-Garcia
Abaete

@lela_rose
Lela Rose

@lemlemnyc
Liya Kebede
LemLem

@lisajenksjewel
Lisa Jenks

@lisaperrystyle
Lisa Perry

@loreerodkin
Loree Rodkin

@lorraineschwartz
Lorraine Schwartz

@luisfern5
Luis Fernandez
Craft Atlantic

@lulu_frost
Lisa Salzer
Lulu Frost

@maiyet
Kristy Caylor
Maiyet

@marahoffman
Mara Hoffman

@marcalary
Marc Alary

@marcjacobsintl
Marc Jacobs

@marymcfaddeninc
Mary Mcfadden

@mattmurphynyc
Matt Murphy

@me_cutandsew
Marc Eckō
Eckō Unlimited, Co.

@meandrojewelry
Robin Renzi
Me&Ro

@melissajoymanning
Melissa Joy Manning

@michaelkors
Michael Kors

@millybymichelle
Michelle Smith
Milly

@mimisojewels
Mimi So

@monicarichkosann
Monica Rich Kosann

@moniquelhuillier
Monique Lhuillier

@moniquepean
Monique Péan

@mpatmos
Marcia Patmos
M.Patmos

@naeemkhannyc
Naeem Khan

@narciso_rodriguez
Narciso Rodriguez

@natoricompany
Josie Natori
The Natori Company

@nicholakstudio
Nicholas Kunz and
 Christopher Kunz
Nicholas K

@nicolemillernyc
Nicole Miller

@officialannasui
Anna Sui

@officialduckiebrown
Steven Cox and Daniel Silver
Duckie Brown

@officiallibertine
Johnson Hartig
Libertine

@officialrodarte
Kate Mulleavy and
 Laura Mulleavy
Rodarte

@ohnetitelny
Alexa Adams and Flora Gill
Ohne Titel

@oscarprgirl
Oscar de la Renta

@ovadiaandsons
Ariel and Shimon Ovadia
Ovadia & Sons

@paigenovick
Paige Novick

@pamelalovenyc
Pamela Love

@pamellaroland
Pamella Roland

@paul_marlow
Paul Marlow

@petersom
Peter Som

@prabalgurung
Prabal Gurung

@publicschoolnyc
Dao-Yi Chow and
 Maxwell Osborne
Public School

@rachel_comey
Rachel Comey

@rachel_roy
Rachel Roy

@rachelzoe
Rachel Zoe

@rafenewyork
Rafe Totengco
Rafe New York

@rag_bone
Marcus Wainwright and
 David Neville
Rag & Bone

@raleighdenimworkshop
Victor Lytvinenko and
 Sarah Yarborough
Raleigh Denim Workshop

@ralphlauren
Ralph Lauren

@rebeccaminkoff
Rebecca Minkoff

@rebeccataylornyc
Rebecca Taylor

@reedkrakoff
Reed Krakoff

@reem_acra
Reem Acra

@reginakravitzco
Regina Kravitz

@richardlambertson
Richard Lambertson
Tiffany & Co.

@robertgeller
Robert Geller

@rodkeenannewyork
Rod Keenan

@rscottfrench
Scott French
R. Scott French

@ruffian
Brian Wolk and Claude Morais
Ruffian

@ruthie_davis
Ruthie Davis

@sachinandbabi
Sachin and Babi Ahluwalia
Sachin + Babi

@salvatorecesarani
Salvatore Cesarani

@sam_edelman
Sam Edelman

@selimaoptique
Selima Salaun
Selima Optique

@shellysteffee
Shelly Steffee

@skearney73
Shaun Kearney

@slowandsteadywinstherace
Mary Ping
*Slow and Steady Wins
 the Race*

@sophiebuhai
Sophie Buhai
Vena Cava

@sophietheallet
Sophie Theallet

@stephendweck
Stephen Dweck

@suestemp
Sue Stemp
St. Roche

@sullybonnelly
Sully Bonnelly

@tabithasimmons
Tabitha Simmons

@tadashishoji
Tadashi Shoji

@talbotrunhof
Johnny Talbot
Talbot Runhof

@tessgiberson
Tess Giberson

@theelderstatesmanofficial
Greg Chait
Elder Statesman Official

@tibi
Amy Smilovic
Tibi

@titleofwork
Jonathan Meizler
Title of Work

@thakoonny
Thakoon Panichgul

@therow
Ashley Olsen and
 Mary-Kate Olsen
The Row

@thisisbandofoutsiders
Scott Sternberg
Band of Outsiders

@thombrowneny
Thom Browne

@toddsnyderny
Todd Snyder

@tommyhilfiger
Tommy Hilfiger

@toms
Blake Mycoskie
Toms

@tracy_reese
Tracy Reese

@trinaturk
Trina Turk

@ullajohnson
Ulla Johnson

@ulrichcps
Ulrich Grimm
Calvin Klein

@vanessanoelstyle
Vanessa Noel

@verawanggang
Vera Wang

@veronicabeard
Veronica Beard

@vincecamuto
Vince Camuto

@vitafede
Cynthia Sakai
Vita Fede

@vplnyc
Victoria Bartlett
VPL

@vsa_designs
Cheryl Finnegan
Virgins Saints & Angels

@whit_ny
Whitney Pozgay
Whit

@xobetseyjohnson
Betsey Johnson

@zeromcornejo
Maria Cornejo
Zero + Maria Cornejo

@31philliplim
Phillip Lim
3.1 Phillip Lim

CFDA MEMBERSHIP ROSTER

Amsale Aberra
Reem Acra
Alexa Adams
Adolfo
Babi Ahluwalia
Sachin Ahluwalia
Waris Ahluwalia
Steven Alan
Marc Alary
Simon Alcantara
Fred Allard
Linda Allard
Joseph Altuzarra
Carolina Amato
Ron Anderson
Miho Aoki
Greg Armas
Nak Armstrong
Brian Atwood
Lisa Axelson
Lubov Azria
Max Azria
Yigal Azrouel
Mark Badgley
Michael Ball
Linda Balti
Jeffrey Banks
Leigh Bantivoglio
Jhane Barnes
John Bartlett
Victoria Bartlett
Gaby Basora
Dennis Basso
Michael Bastian
Shane Baum
Bradley Bayou
Veronica Miele Beard
Veronica Swanson
 Beard
Erin Beatty
Susan Beischel
Stacey Bendet
Richard Bengtsson
Magda Berliner

Coomi Bhasin
Alexandre Birman
Alexis Bittar
Kenneth Bonavitacola
Sully Bonnelly
Eddie Borgo
Monica Botkier
Marc Bouwer
Barry Bricken
Thom Browne
Dana Buchman
Andrew Buckler
Sophie Buhai
Tory Burch
Ben Burkman
Doug Burkman
Stephen Burrows
Anthony Camargo
Carlos Campos
Vince Camuto
Kevin Carrigan
Liliana Casabal
Edmundo Castillo
Kristy Caylor
Jean-Michel Cazabat
Salvatore Cesarani
Richard Chai
Julie Chaiken
Greg Chait
Amy Chan
Natalie Chanin
Kip Chapelle
Georgina Chapman
Ron Chereskin
Wenlan Chia
Susie Cho
David Chu
Eva Chun Chow
Dao-Yi Chow
Doo-Ri Chung
Peter Cohen
Kenneth Cole
Liz Collins
Michael Colovos

Nicole Colovos
Sean Combs
Rachel Comey
Martin Cooper
Tim Coppens
Anna Corinna Sellinger
Maria Cornejo
Esteban Cortazar
Francisco Costa
Victor Costa
Jeffrey Costello
Christian Cota
Erica Courtney
Steven Cox
Keren Craig
Philip Crangi
Angela Cummings
Emily Current
Carly Cushnie
Sandy Dalal
Robert Danes
Mark Davis
Ruthie Davis
Donald Deal
Louis Dell'Olio
Pamela Dennis
Lyn Devon
Kathryn Dianos
Rachel Dooley
Keanan Duffty
Randolph Duke
Stephen Dweck
Marc Ecko
Libby Edelman
Sam Edelman
Mark Eisen
Meritt Elliott
Lola Ehrlich
Karen Erickson
Patrik Ervell
George Esquivel
Steve Fabrikant
Carlos Falchi
Pina Ferlisi

Luis Fernandez
Erin Fetherston
Andrew Fezza
Cheryl Finnegan
Eileen Fisher
Jennifer Fisher
Dana Foley
Tom Ford
Istvan Francer
Isaac Franco
R. Scott French
Shane Gabier
James Galanos
Judy Geib
Nancy Geist
Robert Geller
Geri Gerard
Gai Gherardi
Tess Giberson
Flora Gill
Justin Giunta
Adriano Goldschmied
Gary Graham
Nicholas Graham
Rogan Gregory
Henry Grethel
Ulrich Grimm
Joy Gryson
George Gublo
Prabal Gurung
Scott Hahn
Jeff Halmos
Douglas Hannant
Cathy Hardwick
Karen Harman
Dean Harris
Johnson Hartig
Sylvia Heisel
Joan Helpern
Stan Herman
Lazaro Hernandez
Carolina Herrera
Tommy Hilfiger
Carole Hochman

Mara Hoffman
Swaim Hutson
Sang A Im-Propp
Alejandro Ingelmo
Marc Jacobs
Henry Jacobson
Eric Javits, Jr.
Lisa Jenks
Betsey Johnson
Ulla Johnson
Alexander Julian
Gemma Kahng
Norma Kamali
Donna Karan
Jen Kao
Kasper
Ken Kaufman
Jenni Kayne
Shaun Kearney
Liya Kebede
Anthony Keegan
Rod Keenan
Pat Kerr
Naeem Khan
Sharon Khazzam
Barry Kieselstein-Cord
Eugenia Kim
Adam Kimmel
Calvin Klein
Michael Kors
Monica Rich Kosann
Fiona Kotur Marin
Grant Krajecki
Reed Krakoff
Michel Kramer-Metraux
Regina Kravitz
Devi Kroell
Nikki Kule
Christopher Kunz
Nicholas Kunz
Blake Kuwahara
Steven Lagos
Derek Lam
Richard Lambertson

Adrienne Landau
Liz Lange
Ralph Lauren
Eunice Lee
Jussara Lee
Larry Leight
Nanette Lepore
Michael Leva
Natalie Levy
Monique Lhuillier
Andrea Lieberman
Phillip Lim
Johan Lindeberg
Marcella Lindeberg
Adam Lippes
Deborah Lloyd
Elizabeth Locke
Dana Lorenz
Nili Lotan
Pamela Love
Tina Lutz
Jenna Lyons
Sarah Lytvinenko
Victor Lytvinenko
Bob Mackie
Jeff Mahshie
Catherine Malandrino
Colette Malouf
Isaac Manevitz
Melissa Joy Manning
Robert Marc
Mary Jane Marcasiano
Lana Marks
Paul Marlow
Deborah Marquit
Jana Matheson
Lisa Mayock
Anthony Thomas
 Melillo
Jessica McClintock
Jack McCollough
Mary McFadden
Kimberly McDonald
Mark McNairy
Barbara McReynolds
David Meister
Jonathan Meizler
Andreas Melbostad
Gilles Mendel
Gene Meyer
Jennifer Meyer
B Michael
Carlos Miele

Stefan Miljanic
Derrick Miller
Nicole Miller
Malia Mills
Rebecca Minkoff
James Mischka
Richard Mishaan
Isaac Mizrahi
Lauren Moffatt
Bibhu Mohapatra
Sean Monahan
Claude Morais
Paul Morelli
Robert Lee Morris
Miranda Morrison
Rebecca Moses
Kate Mulleavy
Laura Mulleavy
Sandra Muller
Matt Murphy
Blake Mycoskie
Gela Nash-Taylor
Josie Natori
LeAnn Nealz
Charlotte Neuville
Irene Neuwirth
David Neville
Rozae Nichols
Roland Nivelais
Vanessa Noel
Maggie Norris
Paige Novick
Juan Carlos Obando
Kerry O'Brien
Michelle Ochs
Ashley Olsen
Mary-Kate Olsen
Sigrid Olsen
Luca Orlandi
Maxwell Osborne
Max Osterweis
Ariel Ovadia
Shimon Ovadia
Rick Owens
Thakoon Panichgul
Monica Paolini
Gregory Parkinson
Raan Parton
Shea Parton
Marcia Patmos
John Patrick
Edward Pavlick
Monique Péan

Gabriela Perezutti
Patty Perreira
Lisa Perry
James Perse
Christopher Peters
Thuy Pham
Robin Piccone
Mary Ping
Maria Pinto
Ashley Pittman
Jill Platner
Linda Platt
Tom Platt
Alexandre Plokhov
Laura Poretzky
Zac Posen
Whitney Pozgay
Virginie Promeyrat
James Purcell
Jessie Randall
David Rees
Tracy Reese
William Reid
Robin Renzi
Mary Ann Restivo
Brian Reyes
Judith Ripka
Patrick Robinson
Loree Rodkin
David Rodriguez
Eddie Rodriguez
Narciso Rodriguez
Robert Rodriguez
Jackie Rogers
Pamella Roland
Charlotte Ronson
Lela Rose
Kara Ross
Ippolita Rostagno
Christian Roth
Cynthia Rowley
Rachel Roy
Sonja Rubin
Ralph Rucci
Kelly Ryan
Ernest Sabine
Jamie Sadock
Cynthia Sakai
Selima Salaun
Justin Salguero
Lisa Salzer
Angel Sanchez
Behnaz Sarafpour

Janis Savitt
Arnold Scaasi
Jordan Schlanger
Lorraine Schwartz
Ricky Serbin
Ronaldus Shamask
Arielle Shapiro
George Sharp
Danielle Sherman
Marcia Sherrill
Sam Shipley
Tadashi Shoji
Kari Sigerson
Daniel Silberman
Daniel Silver
Howard Silver
Jonathan Simkhai
Tabitha Simmons
Michael Simon
George Simonton
Paul Sinclaire
Christian Siriano
Sofia Sizzi
Pamela Skaist-Levy
Michael Smaldone
Amy Smilovic
Michelle Smith
Danielle Snyder
Jodie Snyder
Maria Snyder
Todd Snyder
Mimi So
Peter Som
Kate Spade
Gunnar Spaulding
Peter Speliopoulos
Michael Spirito
Simon Spurr
Laurie Stark
Richard Stark
Cynthia Steffe
Shelly Steffee
Sue Stemp
Scott Sternberg
Robert Stock
Steven Stolman
Jay Strongwater
Jill Stuart
Anna Sui
Koi Suwannagate
Daiki Suzuki
Albertus Swanepool
Elie Tahari

Robert Tagliapietra
Johnny Talbot
Vivienne Tam
Rebecca Taylor
Yeohlee Teng
Sophie Theallet
Olivier Theyskens
Gordon Thompson III
Monika Tilley
Zang Toi
Isabel Toledo
Rafe Totengco
John Truex
Trina Turk
Mish Tworkowski
Patricia Underwood
Kay Unger
Carmen Marc Valvo
Nicholas Varney
John Varvatos
Cynthia Vincent
Adrienne Vittadini
Clare Vivier
Diane von Furstenberg
Patricia von Musulin
Marcus Wainwright
Tom Walko
Alexander Wang
Vera Wang
Cathy Waterman
Heidi Weisel
Stuart Weitzman
Trish Wescoat Pound
Carla Westcott
John Whitledge
Edward Wilkerson
Brian Wolk
Gary Wolkowitz
Jason Wu
Araks Yeramyan
Gerard Yosca
David Yurman
Gabriella Zanzani
Katrin Zimmermann
Rachel Zoe
Italo Zucchelli
Eva Zuckerman

THANK YOU TO . . .

Rebecca Kaplan, Zachary Knoll, and Samantha Weiner at Abrams for their guidance and patience;

William van Roden for his creative vision;

the team at Instagram for their partnership and collaboration, and to Kevin Systrom for his foreword;

our contributing designers for their enthusiasm, passion, and dedicated participation in this exciting new book;

and the CFDA staff for always working so hard, in particular Kelsey, Kristine, Emilie, and Sophie for their work on *Designers on Instagram*.

Editor: Rebecca Kaplan
Designer: William van Roden
Production Manager: Denise LaCongo

Library of Congress Control Number: 2014945992

ISBN: 978-1-4197-1558-7

Compilation copyright © 2015 Council of Fashion Designers of America

Published in 2015 by Abrams, an imprint of ABRAMS. All rights reserved. No portion of this book may be reproduced, stored in a retrieval system, or transmitted in any form or by any means, mechanical, electronic, photocopying, recording, or otherwise, without written permission from the publisher.

Printed and bound in the United States
10 9 8 7 6 5 4 3 2 1

Abrams books are available at special discounts when purchased in quantity for premiums and promotions as well as fundraising or educational use. Special editions can also be created to specification. For details, contact specialsales@abramsbooks.com or the address below.

THE **ART OF BOOKS** SINCE 1949
115 West 18th Street
New York, NY 10011
www.abramsbooks.com